John and Caroline

Also by James Spada

Ronald Reagan: His Life in Pictures

Black and White Men (*as photographer*)

Jackie: Her Life in Pictures

Streisand: Her Life

More Than a Woman: A Biography of Bette Davis

Peter Lawford: The Man Who Kept the Secrets

Grace: The Secret Lives of a Princess

Fonda: Her Life in Pictures

Shirley and Warren

Hepburn: Her Life in Pictures

The Divine Bette Midler

Judy and Liza

Monroe: Her Life in Pictures

Streisand: The Woman and the Legend

The Spada Report

The Films of Robert Redford

Barbra: The First Decade

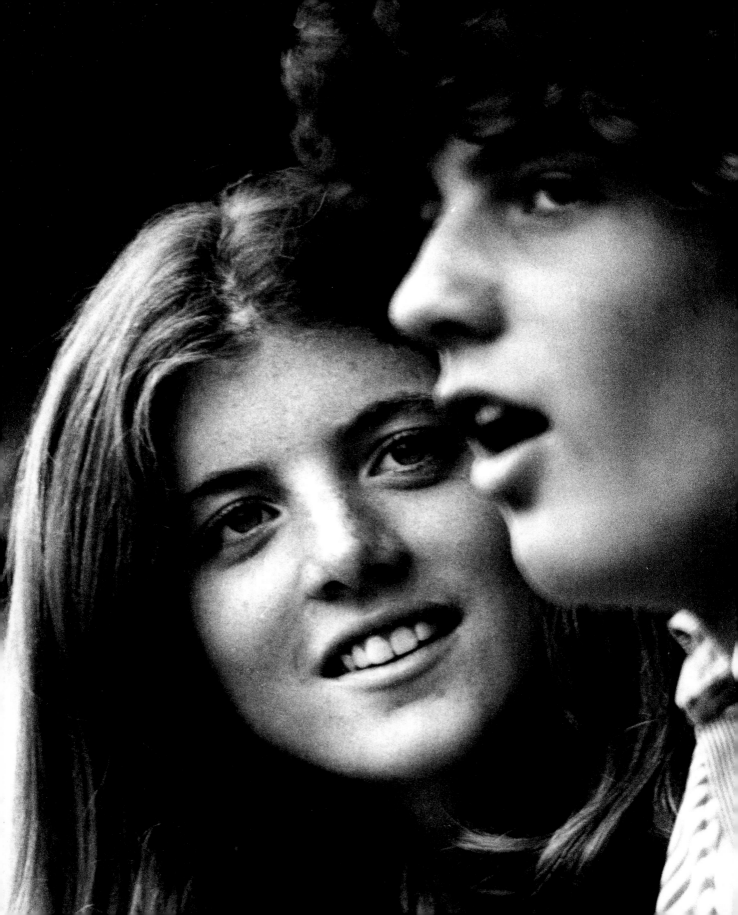

John and Caroline

Their Lives in Pictures

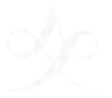

JAMES SPADA

ST. MARTIN'S PRESS ⚞ NEW YORK

For
Richard Branson
and
Ned Keefe,
friends loyal and true

www.stmartins.com

ISBN 0-312-28089-0

FIRST EDITION: JULY 2001

10 9 8 7 6 5 4 3 2 1

Contents

✿

PART ONE *1957–1963* I

PART TWO *1964–1968* 47

PART THREE *1969–1975* 75

PART FOUR *1976–1983* 99

PART FIVE *1984–1994* 121

PART SIX *1995–1999* 157

PART SEVEN *2000* 189

Bibliography 196

Acknowledgments 197

About the Author 199

Photo Credits 200

Three-year-old Caroline Kennedy plays with her infant brother, John, in Palm Beach as their father prepares to become the thirty-fifth President of the United States in January 1961.

1957–1963

"She's as robust as a sumo wrestler."

—JOHN F. KENNEDY on his infant daughter, Caroline, 1957

❧

"John is a bad squeaky boy who tries to spit in his mother's
Coca-Cola and has a very bad temper."

—Three-year-old CAROLINE describing her infant brother, 1961

❧

"Isn't he a charge?"

—JFK on his toddler son, 1963

They were born into singularly charmed lives. Caroline, the first young child of a President in nearly a century; John, the Chief Executive's infant namesake, born just weeks after his father's election.

Charmed, too, were most of the people of America and the world, who watched these children develop adorable personalities and use the White House as a playhouse. They hid underneath the President's desk, danced as their father gleefully clapped his hands. Caroline rode her ponies into the mansion; John sat behind the controls of the President's helicopters and gave orders as Flight Captain John.

Their mother tried to protect them from the intrusions of paparazzi and curiosity seekers, with spotty success. Once, besieged by photographers with flashbulbs popping, Caroline slumped down in her car seat, out of view, and pleaded, "Please tell me when no one's watching."

The idyll came to an abrupt, shocking end when an assassin's bullet shattered the vital young President's skull. Six-year-old Caroline kissed her father's flag-draped coffin, aware of how much she had lost. John, three, saluted his passing caisson but was too young to comprehend just how much his life had been altered.

Now the children, and their mother, had become not just celebrities but icons, symbols as much as people. The President's widow wondered whether, under such circumstances, she could bring them up to be the good, responsible, and emotionally stable people she wanted them to be.

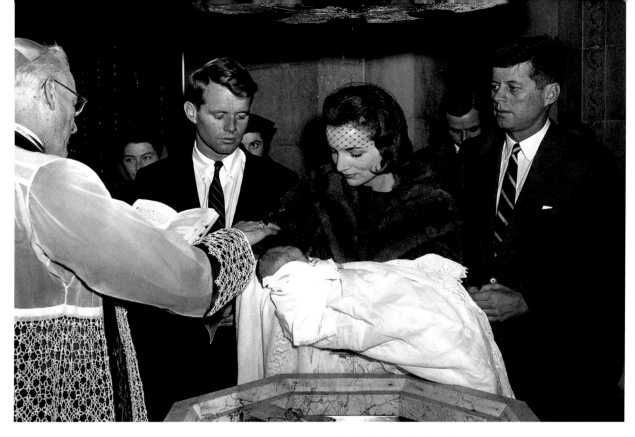

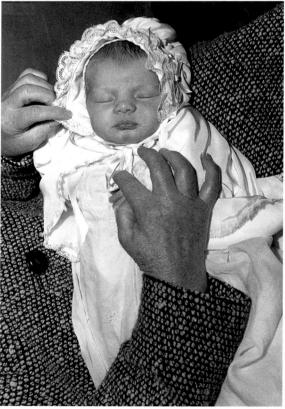

ABOVE Her aunt Caroline Lee Canfield holds sixteen-day-old Caroline Bouvier Kennedy during her christening at St. Patrick's Cathedral in New York City, December 13, 1957. Boston's Archbishop Richard Cushing officiates as the child's father, Massachusetts Senator John F. Kennedy, and her godfather, Robert F. Kennedy, look on. The baby wears the same christening gown her mother, Jacqueline, wore twenty-eight years earlier.

RIGHT Caroline poses for a christening-day portrait. The baby's birth on November 27, the day before Thanksgiving, was a truly blessed event for the Kennedys after a miscarriage and a stillbirth. The child weighed seven pounds, two ounces, and was, according to her father, "as robust as a sumo wrestler." Her mother said the day of Caroline's birth was "the very happiest of my life." Jackie's mother recalled being impressed by the "sheer, unadulterated delight" Jack Kennedy took in his newborn daughter. "The look on his face, which I had never seen before . . . was radiant."

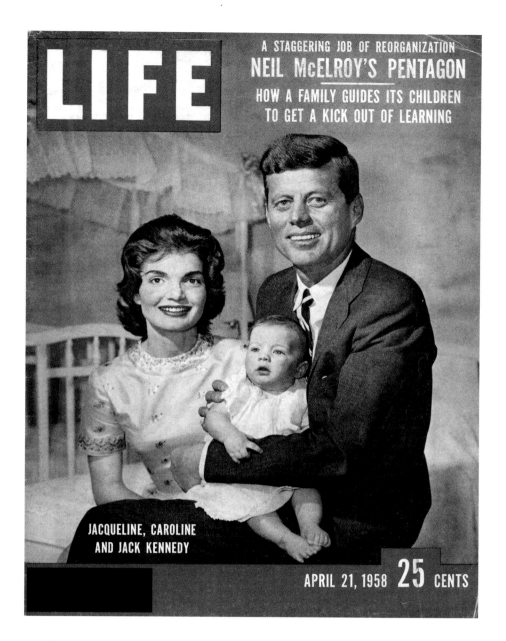

LIFE

A STAGGERING JOB OF REORGANIZATION
NEIL McELROY'S PENTAGON

HOW A FAMILY GUIDES ITS CHILDREN
TO GET A KICK OUT OF LEARNING

JACQUELINE, CAROLINE
AND JACK KENNEDY

APRIL 21, 1958 25 CENTS

Caroline Kennedy's first magazine cover, April 21, 1958. Jackie had initially re-
fused *Life*'s request to do a photo feature on her baby, telling Jack that "I'm not
going to let our child be used like some campaign mascot" for his Senate reelec-
tion bid that November. But she relented when he promised to take a break from
campaigning to spend time with his family that summer. The accompanying arti-
cle ran a photo of Caroline, eyes as big as saucers, peering over her bassinet at her
father. "I'm not home much," the caption quoted Kennedy, "but when I am she
seems to like me."

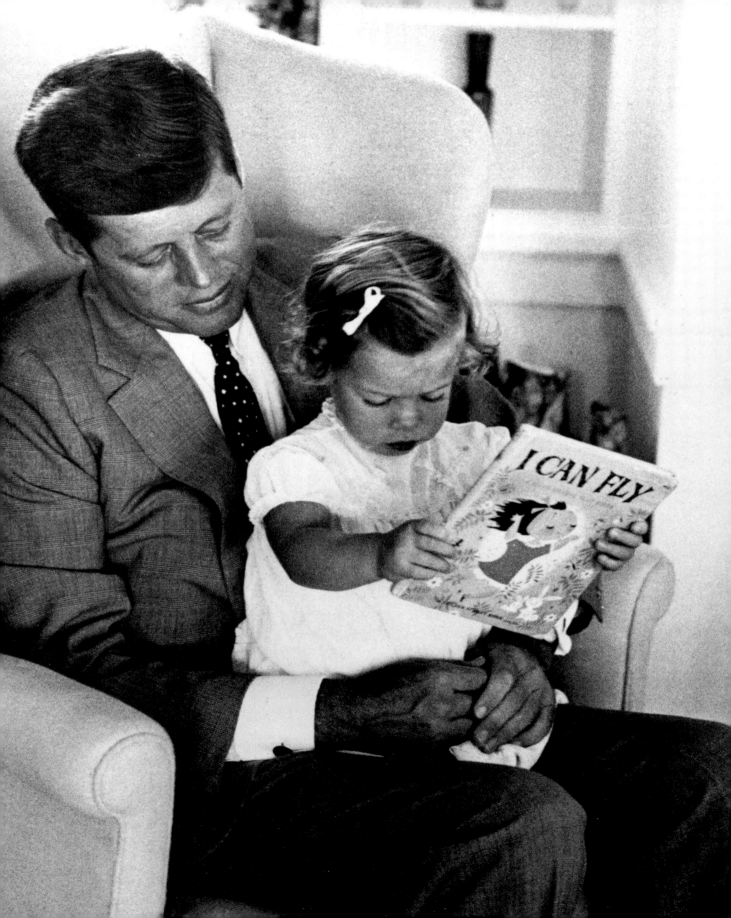

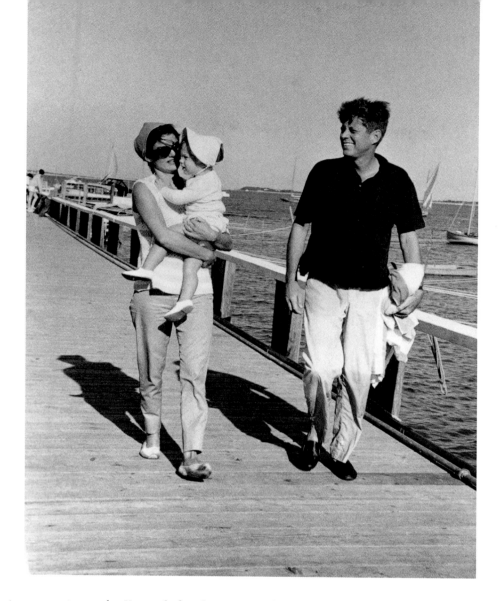

ABOVE During a vacation at the Kennedy family compound in Hyannis Port, Massachusetts, in August 1959, Jackie carries Caroline to shore after a sailing excursion on Nantucket Sound. The Kennedys loved these care-free days with their daughter, but knew that they would soon be rare, since Jack, reelected to the Senate in a landslide, planned to announce his candidacy for President in January. Jackie fretted about the campaign's possible effect on Caroline. "I get this terrible feeling," she said, "that when we leave, she might think that it's because we don't want to be with her."

OPPOSITE During the same vacation, her father prepares to read to twenty-one-month-old Caroline. The child showed above-average intelligence, and an interest in reading, at an early age.

The Senator had made a stab at bottle-feeding the baby when she was an infant, but her nurse, Maud Shaw, recalled, "I fear the whole process was too slow for him, and after about ten minutes he handed her back to me with a smile. 'I guess this is your department after all,' he said. 'I had better leave it to you.'"

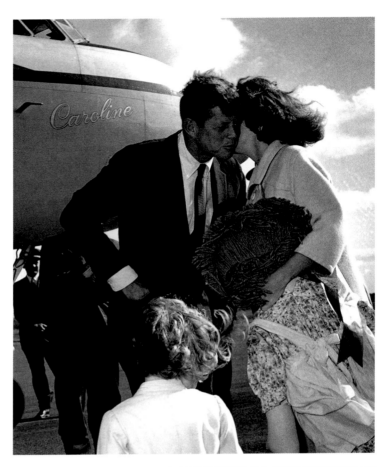

TOP Holding Caroline's oversize Raggedy Ann doll, "Mother Annie," Jackie kisses her husband farewell as he leaves Hyannis Airport for a campaign trip in October 1960. Caroline waits her turn to say good-bye to Daddy. Kennedy had won the Democratic nomination for President in July after a bruising series of primaries. Jackie reported that Caroline's first words were "good-bye," "New Hampshire," "Wisconsin," and "West Virginia."

"I am sorry so few states have primaries," Jackie quipped, "or we would have a daughter with the greatest vocabulary of any two-year-old in the country."

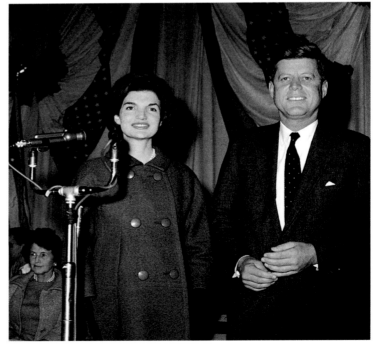

BOTTOM The Kennedys beam at a press conference in Hyannis Port the day after Jack won election as the thirty-fifth President of the United States. Mrs. Rose Kennedy, the President-elect's mother, sits at left. According to Maud Shaw, it was Caroline who had informed her father that he had won the election—which was still undecided when Kennedy went to bed at four in the morning—by entering his bedroom and declaring, as Miss Shaw had instructed her to, "Good morning, Mr. President."

At the conclusion of this press conference, Jack gestured at his eight-and-a-half-months pregnant wife and said that they would now begin to prepare "for a new administration—and a new baby."

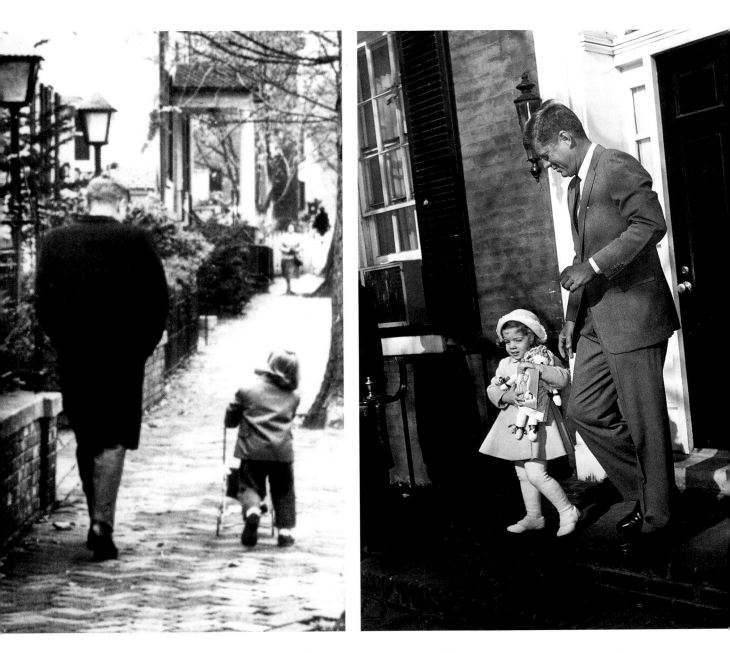

ABOVE LEFT Friday, November 25, 1960: Caroline and her father stroll the streets near their home in Georgetown hours after Jackie gave birth to a six-pound, three-ounce son—and Presidential namesake—John F. Kennedy Jr.

ABOVE RIGHT Two days later, Caroline's third birthday, she and her father leave home for church services. Caroline is dressed in a pink coat and bonnet, blue dress, and knit leggings, and clutches her doll, "Raggedy Annie," and a church book. Jackie would remain in the hospital for another two weeks after a difficult cesarean delivery.

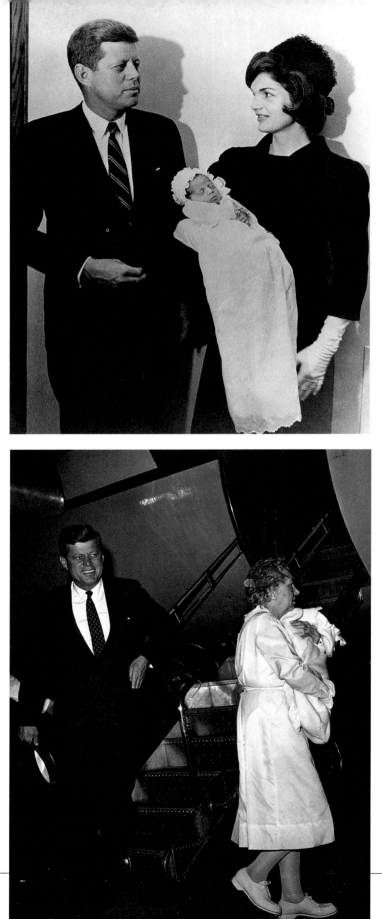

TOP The proud parents show off John Jr. after his baptism in the chapel of Georgetown University Hospital on December 8. Two weeks premature, the child spent his first six days in an incubator, and his mother was unable to hold him until doctors deemed him able to breathe on his own.

"Look at those eyes," Jackie marveled when John Jr. first opened his. "Isn't he sweet?" The President-elect agreed. "Now, that's the most beautiful boy I've ever seen," he said when he first saw his son. Then he joked, "Maybe I'll name him Abraham Lincoln."

BOTTOM John's temporary nurse, Elsie Phillips, carries him as he and his father arrive in Palm Beach on December 9. The extended Kennedy family traditionally spent the Christmas holidays at the family patriarch, Joseph Kennedy's, Florida beach house. During this visit Jackie recuperated from the delivery, Jack put together his cabinet, and Caroline got to know her baby brother. Maud Shaw told Caroline that the baby was a "birthday present" for her, and "she always thought for a long time after that that he sort of belonged to her."

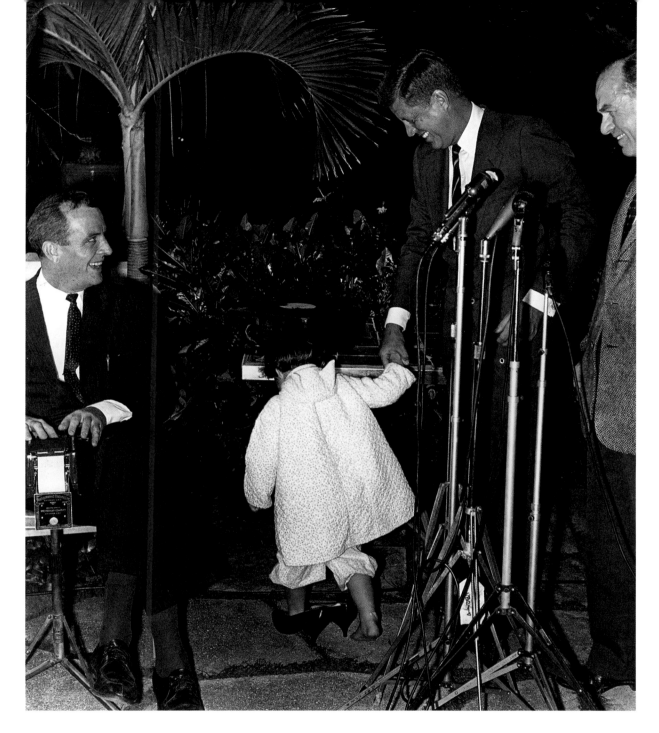

Caroline interrupts her father's December 29 press conference in Palm Beach to ask for assistance with her mother's high heels. A stenographer and Senator J. William Fulbright of Arkansas (*right*) enjoy the diversion.

America quickly became enchanted with this adorable little girl her father called "Buttons"—much to the frustration of the new President's political foes. "How the hell do we compete with Caroline?" one of them grumbled. His daughter's appeal wasn't lost on Kennedy, who told Maud Shaw, "Caroline is a great hit with everyone. I think she could be the greatest vote-getter of all!"

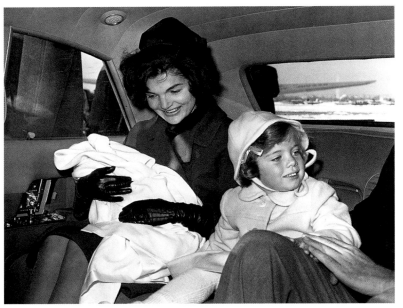

TOP The First Lady holds John Jr. as Caroline excitedly awaits their departure from Washington National Airport for the White House on February 4, 1961. While their parents had settled into their new home after the President's inauguration on January 20, the children remained in Palm Beach. During that time, baby John's health took a turn for the worse when he developed a lung inflammation (the same illness that would later claim the life of his newborn brother, Patrick Kennedy). Luckily, Jackie said, a "brilliant" Palm Beach pediatrician "really saved his life, as he was going downhill."

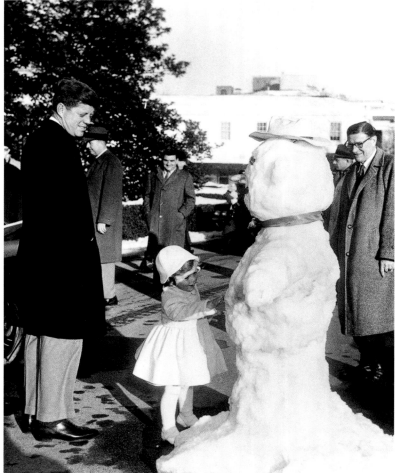

BOTTOM Caroline made a dash for this snowman next to the White House driveway as soon as the limousine doors were opened. After settling into her bedroom, Caroline complained to her grandmother Rose about baby John's behavior during the trip from Palm Beach. "John is a bad squeaky boy who tries to spit in his mother's Coca-Cola and has a very bad temper."

Caroline was thrilled when she saw the White House. "There's so much room to play—and a great big garden, too!" she exclaimed.

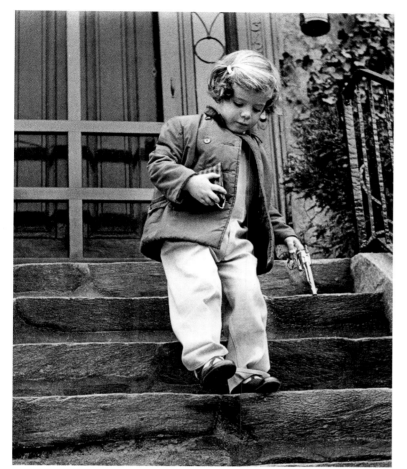

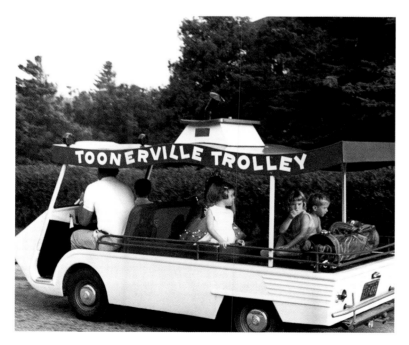

TOP On March 5, Caroline carries a toy pistol as she leaves the Georgetown home of her aunt and uncle Jean and Stephen Smith to rejoin her father on his way back from Sunday services. Now almost three and a half, Caroline had begun to show a tomboy side.

BOTTOM Six months later, as the Kennedys vacationed again in Hyannis Port, Caroline and several of her cousins rode the "Toonerville Trolley," the children's preferred mode of transportation around the sprawling grounds of the Kennedy compound and beyond. This trip was to a candy store.

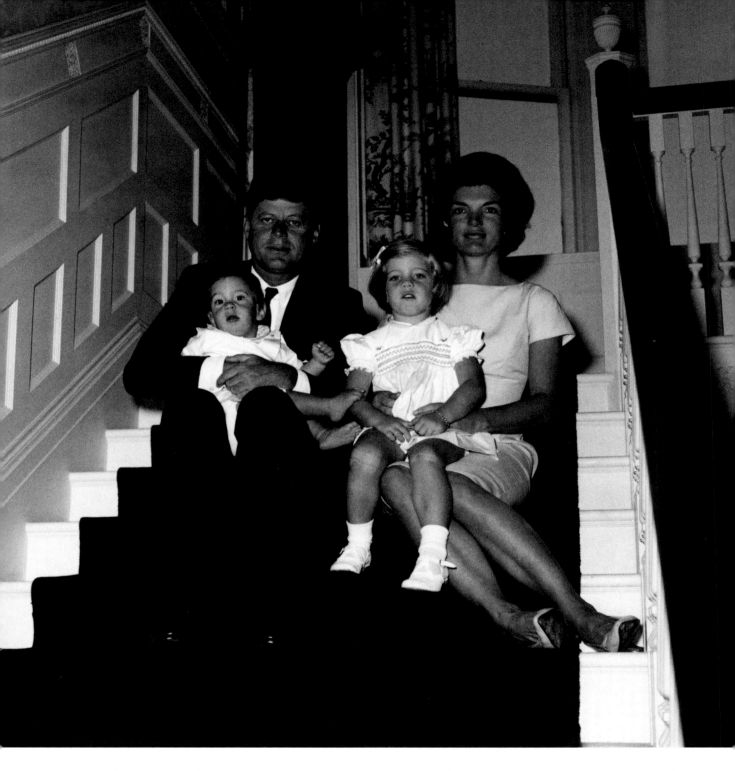

September 9, 1961: The John F. Kennedys pose on the staircase of Hammersmith Farm in Newport, Rhode Island, where Jackie spent the latter half of her teenage years after her mother married multimillionaire Hugh D. Auchincloss. It was at the top of these steps that Jackie stood to throw her bridal bouquet after her wedding eight years earlier.

The official White House portrait of John F. Kennedy Jr., released on November 16 in anticipation of his first birthday nine days later. The boy had already evinced a rambunctious personality and curiosity. Watching his son get into everything within reach, the President looked at an aide and said, "Isn't he a charge?"

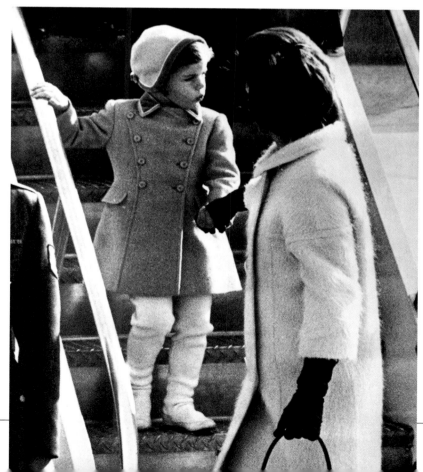

Caroline displayed a little rambunctiousness herself on November 27, her fourth birthday. Descending the ramp of *Air Force One* at Andrews Air Force Base, Maryland, after their arrival from Hyannis Port, Caroline balked at her mother's tugs after something on the tarmac caught her eye.

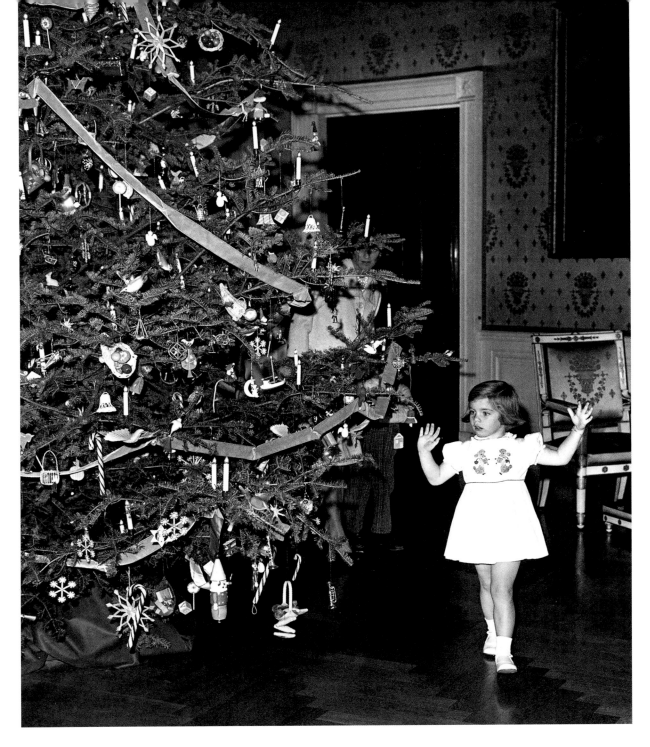

The enormous, festive White House Christmas tree dazzles Caroline after its lighting on December 9. Peering out from behind the tree are Jean Kennedy Smith and her son Stephen Smith Jr. Around this time Caroline expressed a desire to telephone Santa Claus with her holiday wish list. The President arranged for the White House switchboard to put through a call to the North Pole. "Miss Shaw! Miss Shaw!" Caroline bubbled to her nurse. "I just talked to Mrs. Santa Claus! I left a whole list of presents for me and John!"

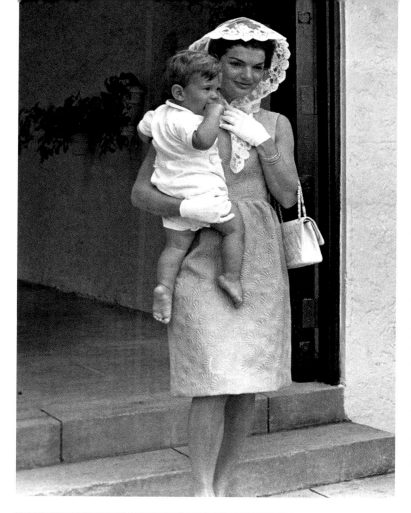

TOP Easter Sunday, April 22, 1962: The First Lady carries barefooted John from the Kennedy home in Palm Beach after a private family Mass. John had been a little late in learning to talk, and the President once expressed concern. "Oh, but he does talk," Maud Shaw replied. "It's just that you don't understand him."

"That's right, Daddy," Caroline piped up. "He does talk to me."

"Well, I guess you'd better interpret for me," the President said with a laugh.

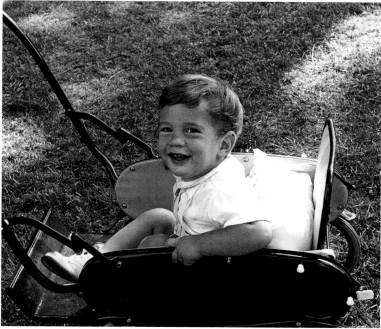

BOTTOM John gives White House photographer Cecil Stoughton a big smile from his carriage on May 17. After limiting the official photographers' access to her children their first year in the White House, Jackie allowed Stoughton and his colleagues Abbie Rowe and John Knudsen fairly free rein after that. John Jr. had begun to enjoy being photographed, and loved to mug for the cameras. Whenever he saw Stoughton, an army captain, John would call out to him, "Take my picture, Taptain Toughton!" Stoughton did, hundreds of times. "I never made a bad picture of the children," he said. "You couldn't. All you had to do was aim the camera and shoot."

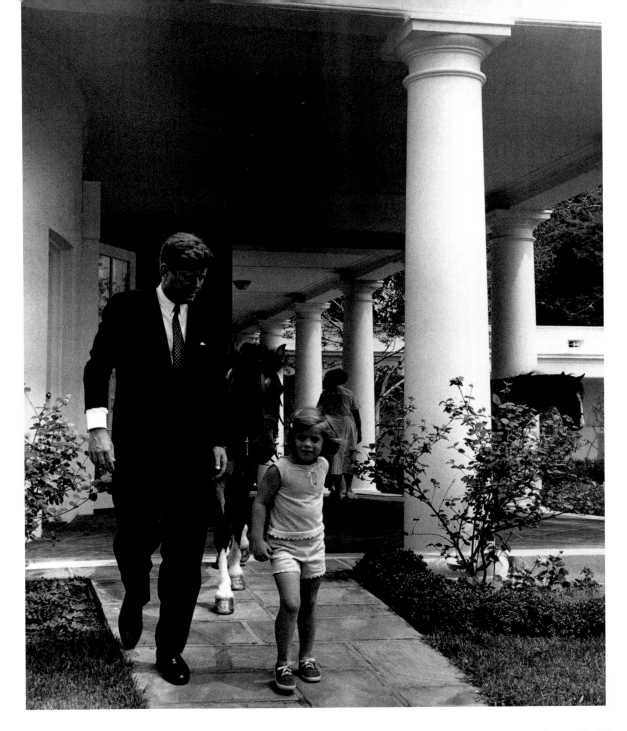

The President keeps an eye on Caroline as she guides her pony along the West Wing portico on June 23. Like her mother and maternal grandmother before her, Caroline was groomed as an equestrian at an early age. "Caroline was a natural horseback rider because she moved so well and so gracefully, with a wonderful sense of balance," Maud Shaw recalled.

Caroline and John kept a virtual menagerie in the White House, which included—in addition to horses— dogs, canaries, parakeets, hamsters, and two deer.

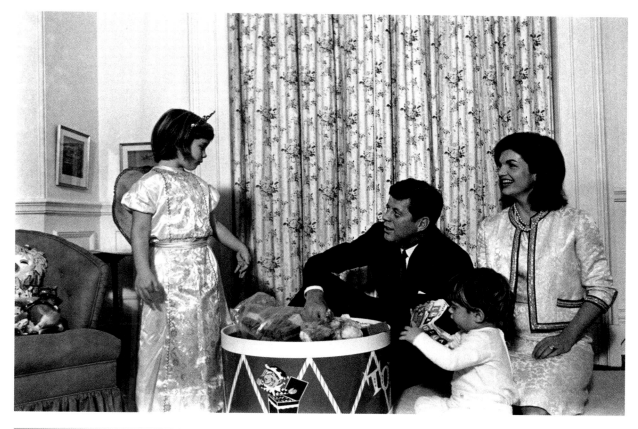

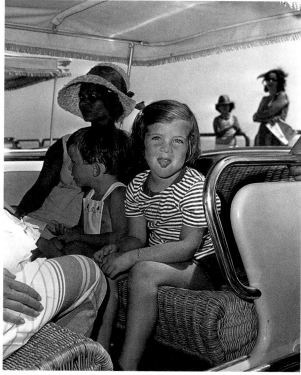

ABOVE In August 1962, the Presidential family poses for Cecil Stoughton in the White House nursery. While John plays with his toys, Caroline models a ceremonial dress given to her mother as a gift for the little girl during Jackie's trip to India earlier in the year. The President had dropped by the photo shoot at the last moment.

LEFT Caroline lets photographers know how she feels about their constant presence during a five-week vacation with her mother in Ravello, Italy, on August 19. The two were guests of Jackie's sister Lee and her second husband, Prince Stanislas Radziwill. Mother and daughter water-skied, sailed aboard a yacht, shopped, toured ancient cathedrals, and were serenaded by an Italian military band.

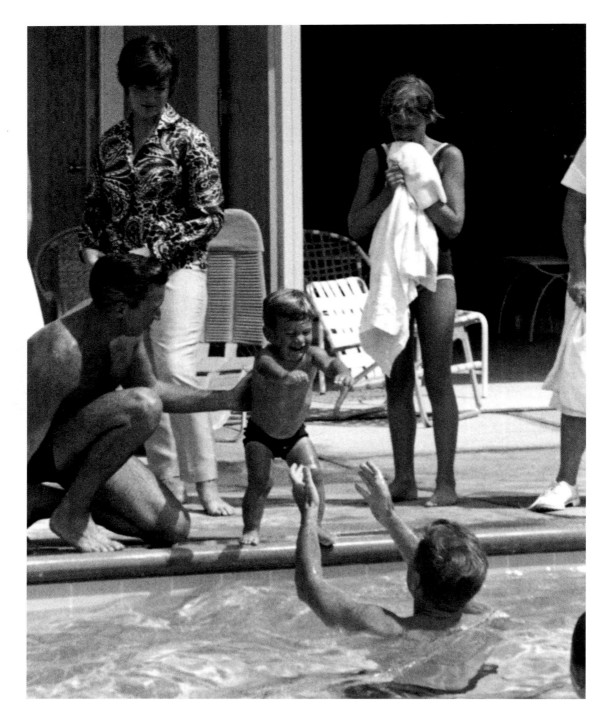

Meanwhile, back in the States, President Kennedy frolicked with his son at the Kennedy compound in Hyannis Port, urging him to take the plunge into the family swimming pool. "John was never scared of the water," Maud Shaw recalled. Often, after John had been for a swim at the beach, Shaw would dry and dress him, turn to do the same with Caroline, and soon find that the boy had run back into the water, fully clothed. "Then I'd just have to take him back to the house dripping wet, his little feet squelching in their shoes."

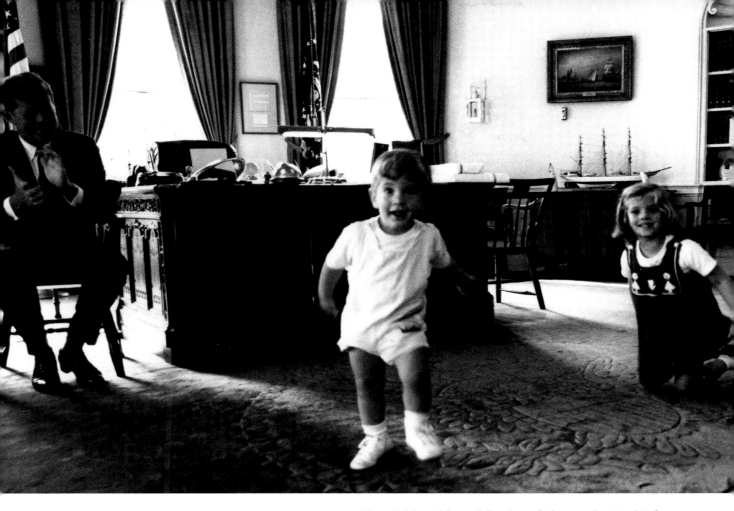

ABOVE The children "dance" for their father in the Oval Office on October 10. The President inscribed a similar picture to Captain Stoughton, "who captured beautifully a happy moment at the White House." Years later Caroline said, "I remember many of the same things people remember about me [as a child]: hiding with my brother under my father's desk, riding my pony, watching the helicopters take off and land. I also remember other things that people don't know about, like the bedtime stories [my father] made up especially for me."

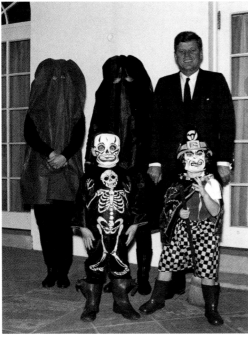

LEFT Halloween 1962: President Kennedy (disguised as President Kennedy) joins Jackie, her sister Lee, Lee's son Tony Radziwill (in skeleton costume), and Caroline on the West Wing portico. Jackie took the children trick-or-treating in Georgetown, but their hoped-for anonymity was shattered by the presence of the stern Secret Service agents who accompanied them.

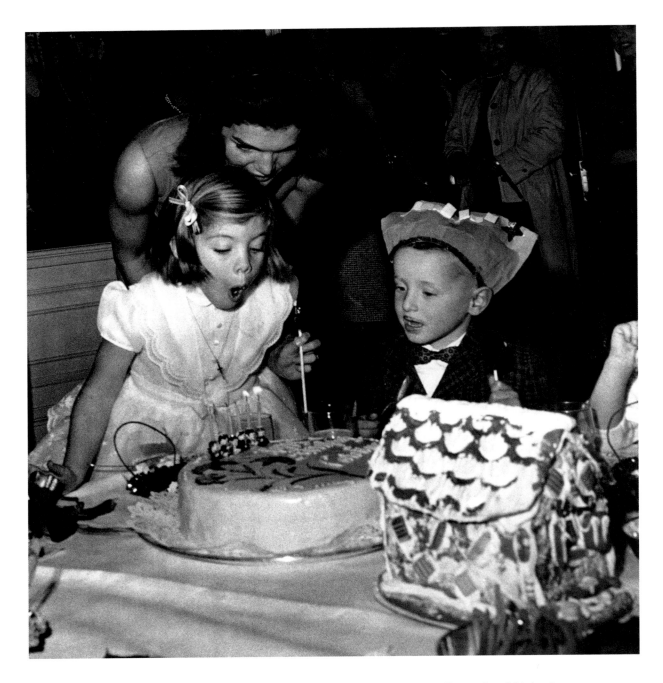

Jackie stands by ready to help as Caroline blows out the candles on her fifth birthday cake, November 27, 1962. The children of White House staffers joined in the celebration.

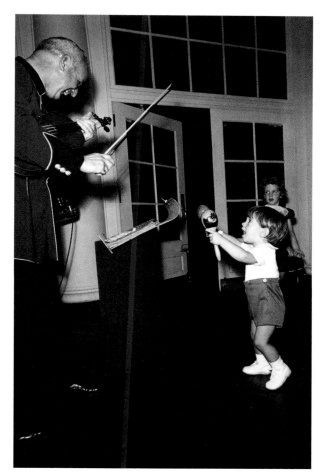

LEFT And so did John, whose second birthday was also celebrated that day. A pair of mariachis captivated him for a while, and he joined the musicians in a spirited, if discordant, performance.

BELOW John and Caroline play with a coloring book amid strewn gift-wrapping as they open the dozens of presents they received. Caroline's name was a little difficult for John to say at this point, so he called her "Cannon."

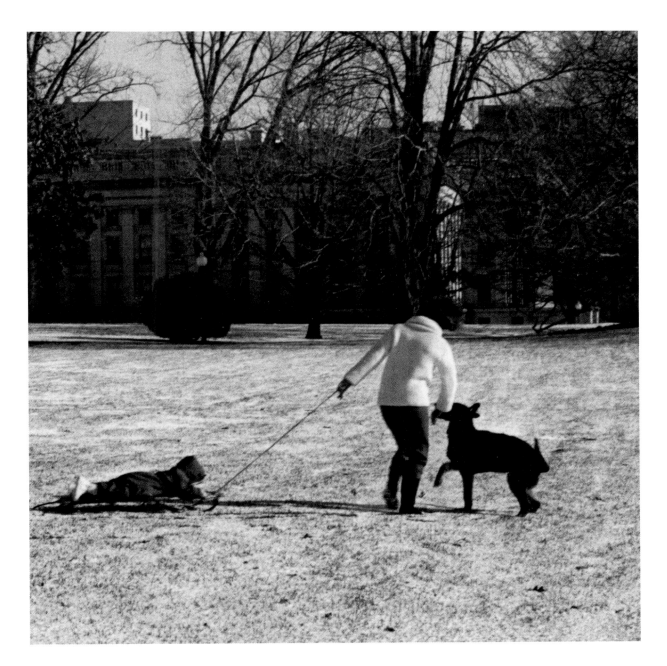

ABOVE The first light dusting of snow in Washington early in December prompted Jackie to take John on a sled ride around the White House grounds with their dog, Clipper. Later the President joined them.

OPPOSITE Caroline looks a tad guilty as she's caught cadging some Christmas chocolates in one of the White House offices on December 4.

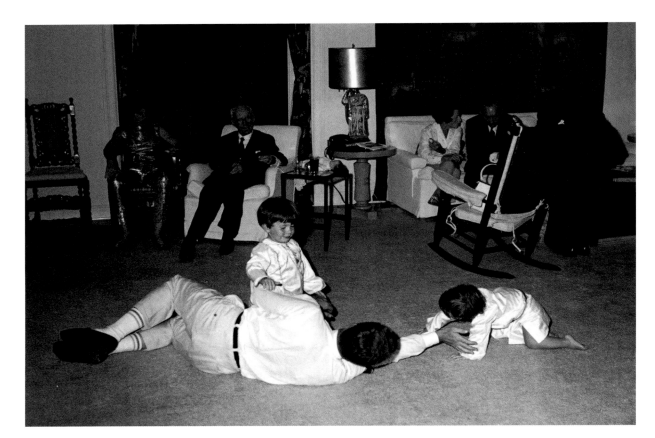

ABOVE Christmas Day in Palm Beach: Joe Kennedy looks on as the President plays with John and one of his cousins. His bad back prevented Jack Kennedy from picking up his children, so he frequently gamboled on the floor with them instead.

RIGHT Caroline plays the Virgin Mary and Gutavos Parades, the son of Jackie Kennedy's personal attendant, Providencia Parades, is a wise man during a Christmas play put on by Jackie for her father-in-law.

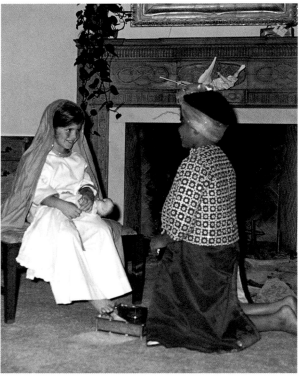

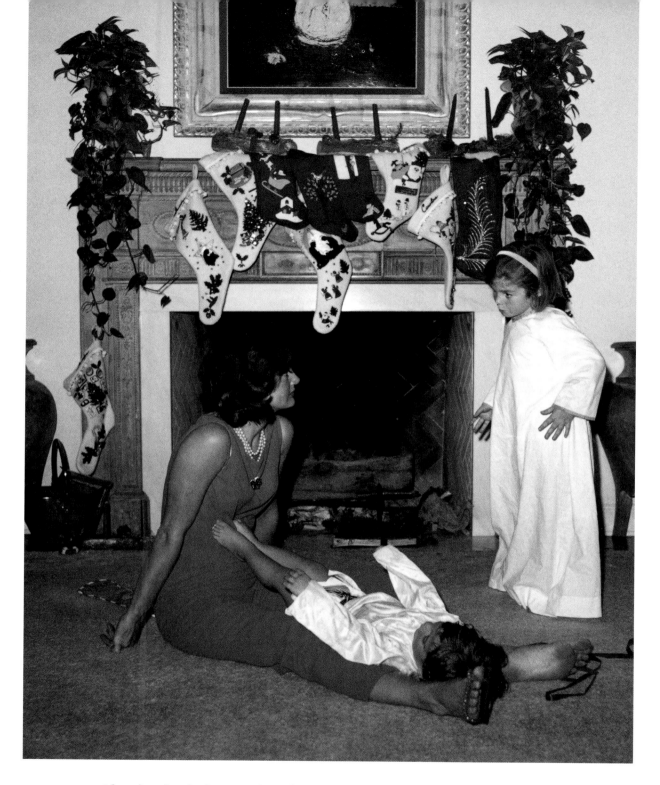

After the play, Jackie provides John with a comfortable resting place. Caroline seems to be beseeching her mother for a critique of her performance.

TOP In President Kennedy's secretary Evelyn Lincoln's office on January 21, 1963, John plays with a toy helicopter and a picture of the Presidential chopper—and shows off the gap in his smile caused by a tooth he lost in a fall outside the White House a few days earlier. The mishap left the child in tears, but once Maud Shaw had calmed him down, he ran back to recover the tooth, and spent the next months smiling broadly at anyone who looked his way.

BOTTOM March 31, 1963: John delighted in the airplanes and helicopters that frequently transported the Kennedys. He never failed to ask if he could "take the controls," and the pilots were happy to oblige if time permitted before takeoff. He called the helicopters "lo-pacas" and would jump with delight and scream, "The choppers are coming! The choppers are coming!" whenever he saw them. At Camp David, when the President usually had more time to spend with his children, he and John could frequently be found in a hangar, behind the controls of a helicopter, both of them wearing flight helmets, the leader of the free world taking orders from his son, Flight Captain John.

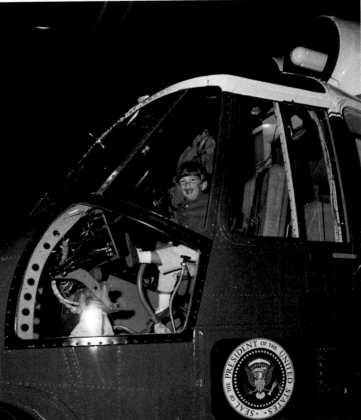

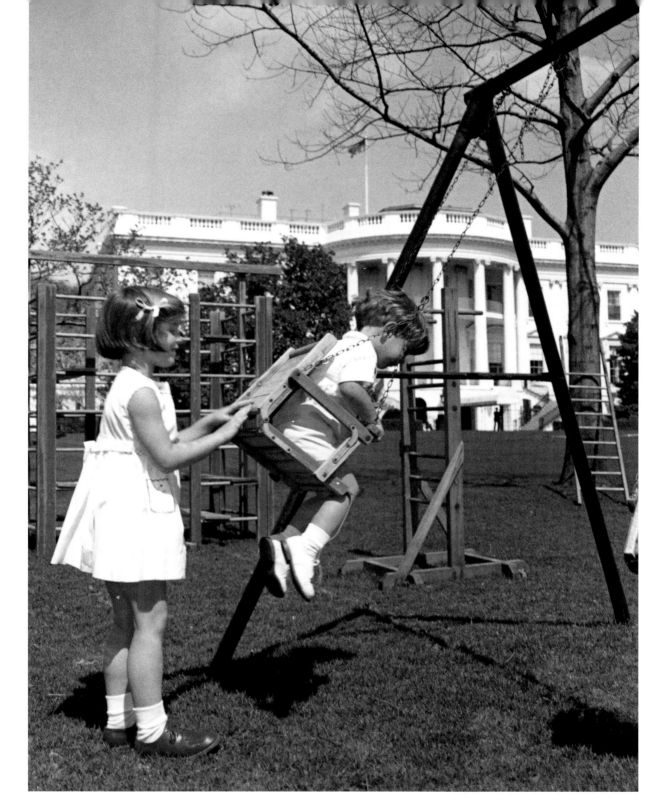

The next day, the first warm day of spring in Washington, Caroline pushes her brother's swing in the children's playground on the south grounds of the White House.

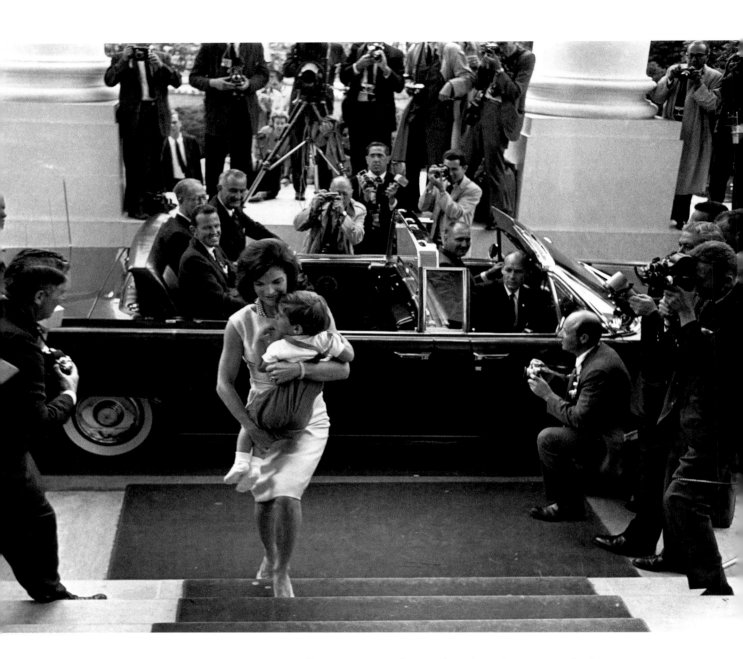

On May 21, astronaut Gordon Cooper was honored at the White House for his twenty-two-orbit space mission, and John insisted on meeting him. Jackie carried him to the limousine carrying Cooper, Senator Clinton Anderson of New Mexico, and Vice President Johnson. The space hero shook John's hand, and then Jackie carried him back inside.

LEFT The day before Easter 1963, Jackie and John color eggs in Palm Beach. Jackie is four months pregnant.

BELOW Riding a golf cart at Camp David, Caroline makes faces at photographer Stoughton, much to the amusement of Secret Service agent Bob Foster. Maud Shaw and the agents protecting Caroline got a scare when she disappeared at the family's Glen Ora, Virginia, farm and did not respond to repeated calls of her name. When an agent told Shaw, "We are going to have to search down by the ponds," she felt on the verge of tears. Then Caroline's voice called out, "Miss Shaw!" and the nurse saw her climbing out of a chicken coop. Instinctively, she gave Caroline "a hard smack on the bottom."

"You naughty girl!" Shaw cried. "Never, never hide from me again!" "But I wasn't hiding from you," the bewildered Caroline replied. "I was playing with my dollies in the little house." All Shaw could do was hug the child with relief.

Caroline tries to stop John from snatching one of her dolls during a play session in the White House. Although the two usually got along well, Caroline could sometimes throw her older-sister weight around. "She was always after him, 'John, do this' and 'You're not supposed to do that, John,'" said Rose Kennedy's former secretary Barbara Gibson. Even when Caroline wasn't bossing him, John frequently showed jealousy at her superior position as the firstborn. During one period, Caroline badgered everyone in the White House for answers to riddles she posed to them. John attempted to do the same. "I know a riddle, too," he would tell Maud Shaw. When she asked what it was, he would brightly reply something like, "Um . . . apples, giraffes, and alligators."

"I'm afraid you've stumped me," Shaw would say, and John would chuckle that he had put one over on Miss Shaw yet again.

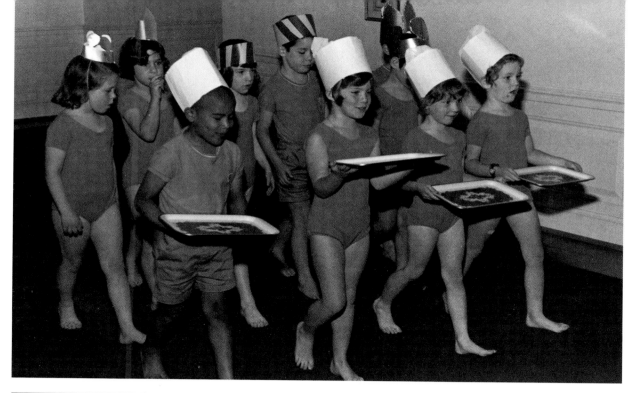

ABOVE The First Lady established a kindergarten for Caroline and the children of staff members, friends, and various embassies' employees in the third-floor solarium at the White House. On May 24, the children put on a ballet recital for their parents with a "White House chefs" theme. The mansion's vast kitchens, equipped to produce state dinners for hundreds, proved a favorite playground for John, who was, according to Maud Shaw, "forever trotting into the kitchens to play with the pots and pans, rifling the shelves to get down egg poachers, milk pans and things like that to make a little shop or a kitchen of his own in the corner."

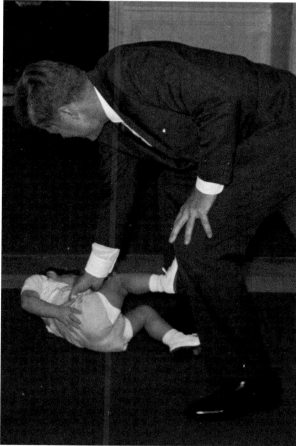

LEFT Five days later, on his forty-sixth birthday, the President tickles his son in a White House hallway. Kennedy delighted in both his children, whom he would regale with stories of the White Whale, which always seemed to trail the Presidential yacht *Sequoia* whenever they were aboard. The fish had a hunger for men's socks, which often had to be supplied by friends and aides of the President's who happened to be onboard.

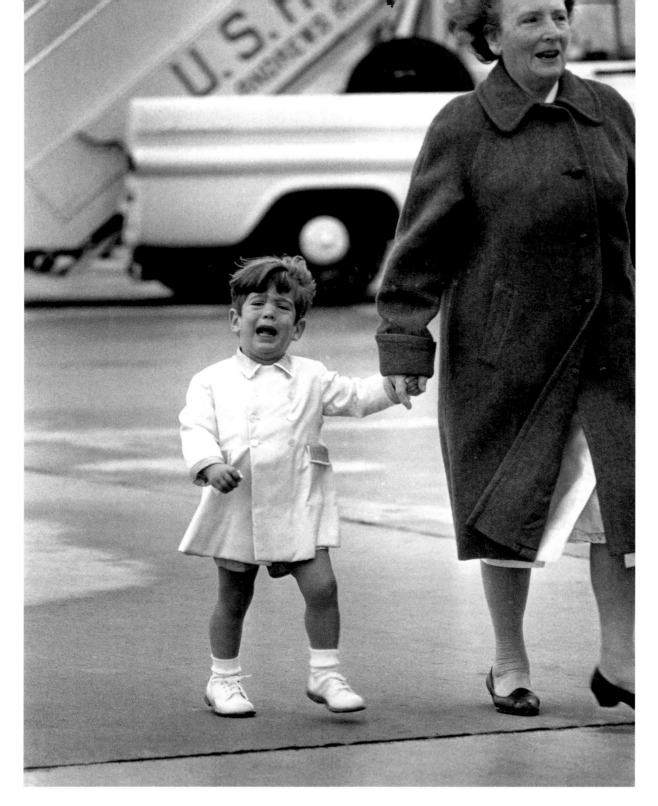

John hated to be separated from his father, and here he shows his displeasure on June 5 as the President leaves for a trip to the West Coast and Hawaii.

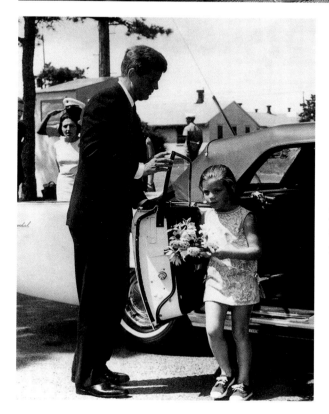

ABOVE August 4, 1963: Caroline takes a nap while her mother catches up on her reading aboard the *Sequoia* on Nantucket Sound. Jackie and the children were on an extended holiday intended to allow Jackie to rest in anticipation of the birth of her third child in September.

LEFT One week later, the President and Caroline pay the First Lady a visit at the Otis Air Force Base Hospital, where she lay recuperating from the birth of her second son, Patrick. The infant had died from a respiratory ailment two days after his cesarean delivery.

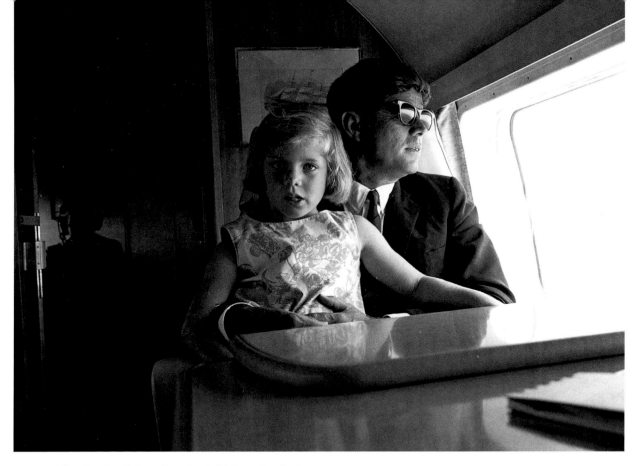

ABOVE The death of their fourth child (another baby, Arabella, had been stillborn in 1956) brought Jack and Jackie closer together and made both parents cherish John and Caroline all the more. Here, on August 13, the President holds Caroline close as they return to Washington aboard *Air Force One*.

RIGHT On August 25, two-and-a-half-year-old John mugs for the camera as he playacts at steering a powerboat off Hyannis Port. John, like his father, loved the sea and sand. He especially enjoyed building sand castles—and liked even more tearing them apart when he was done. When his sister did the same, however, he would run to Maud Shaw and cry, "Caroline stepped in my castle!"

Shaw recalled, "Peace could only be restored if I got down on my hands and knees and helped construct another bigger, better castle for him."

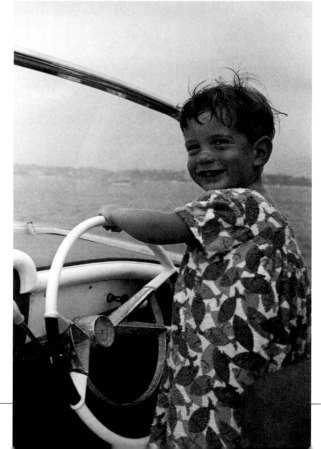

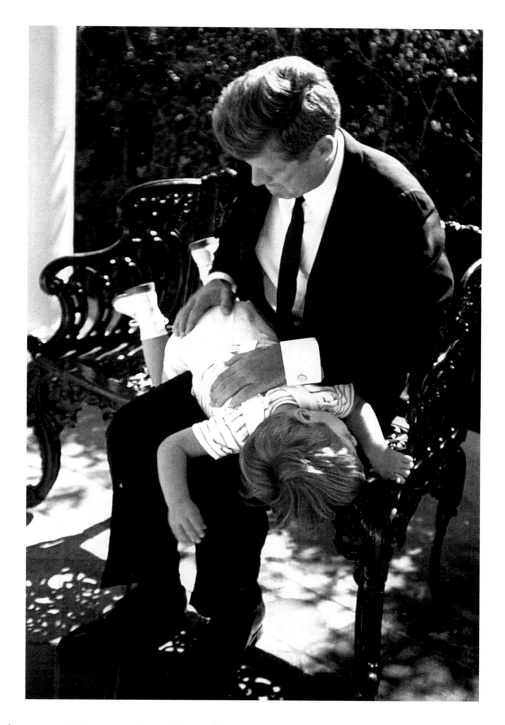

The President gives John a good spanking after what must have been egregious misbehavior, because Kennedy loathed disciplining his son. The President's longtime friend George Smathers recalled, "While Jackie tried to keep him under control, Jack would let him break into meetings, interrupt his schedule, and give him whatever he wanted. Jack adored him, thought he was perfect, and wanted to be with him all the time."

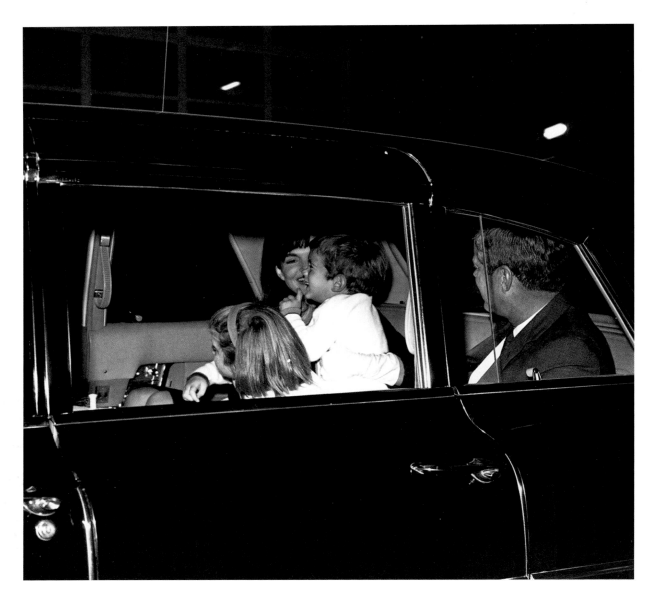

October 17: "I'm so glad to be home!" A delighted Jackie Kennedy greets her husband and children at Dulles International Airport in Washington after her return from a recuperative vacation in Greece. She cruised the Aegean Sea aboard Greek shipping tycoon Aristotle Onassis's yacht *Christina*.

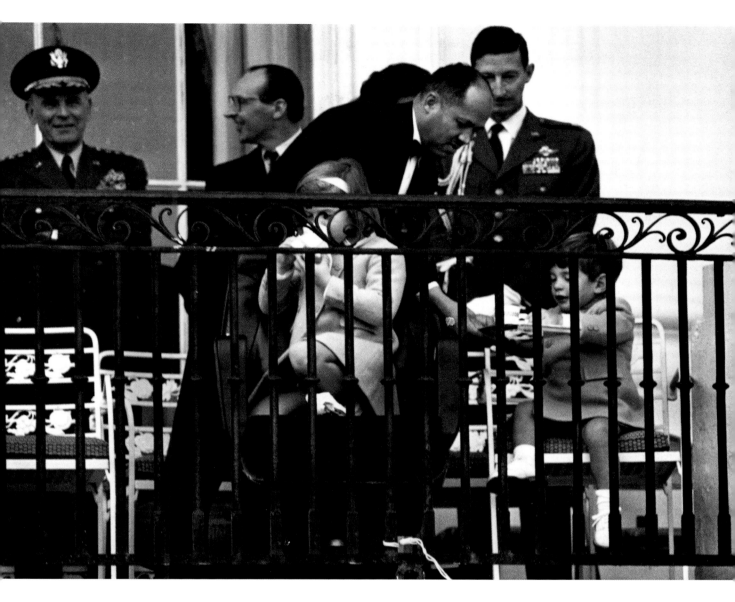

On November 13, John and Caroline warm up with some tea as they await the arrival of their parents for a performance of bagpipe music by Britain's Black Watch Regiment.

On November 22, 1963, John and Caroline lost their father to an assassin's bullet in Dallas, Texas. When a tearful Maud Shaw broke the news to Caroline that night, the child burst into tears and remained inconsolable for hours. The next day Caroline saw a picture of her father in the newspaper, framed in black, and asked her maternal grandmother, Janet Auchincloss, who it was. When Janet replied that surely Caroline knew that was her father, the little girl replied, "A man shot him, didn't he?" Janet found herself unable to reply. Bobby Kennedy informed John, who didn't seem to comprehend that his father was never coming home.

Two days later, Jackie Kennedy led her children and their aunts and uncles up the steps of the Capitol as the President's casket was borne into the rotunda, where it was to lie in state.

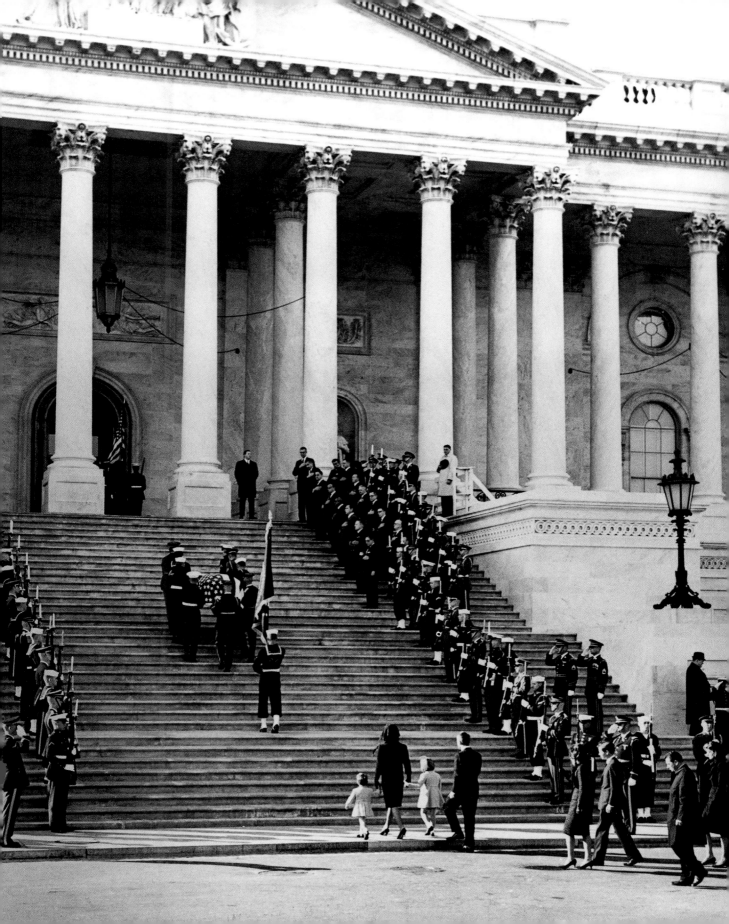

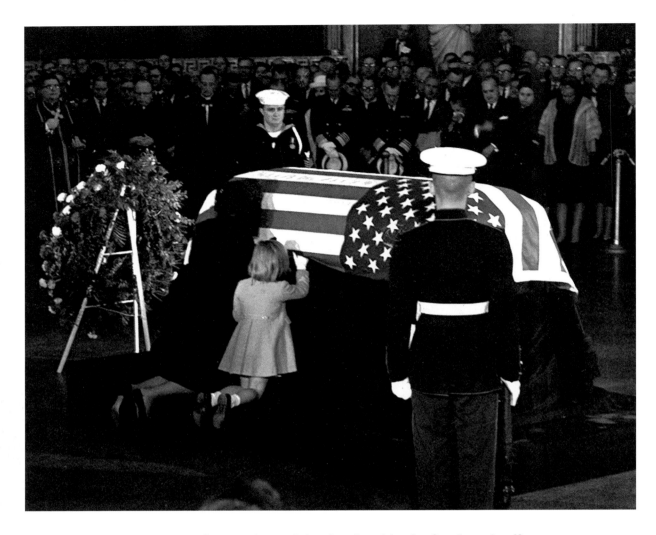

ABOVE Moments later, Jackie and Caroline kneel by the flag-draped coffin in a gesture of farewell. Caroline slipped her hand under the flag, as if to be closer to her daddy. Jackie had asked the children to compose letters to their father. Caroline wrote, "Dear Daddy—We're all going to miss you. Daddy, I love you very much. Caroline." John scribbled an X at the bottom of Caroline's note.

OPPOSITE The gesture that broke millions of hearts. After a whispered reminder from his mother, John salutes his father's passing casket on November 25 as horses pull it on a caisson through the streets of Washington for the President's burial in Arlington National Cemetery.

The first letter Lyndon B. Johnson wrote as President was to John: "It will be many years before you understand fully what a great man your father was," he said. "His loss is a deep personal tragedy for all of us, but I wanted you particularly to know that I share your grief. You can always be proud of him."

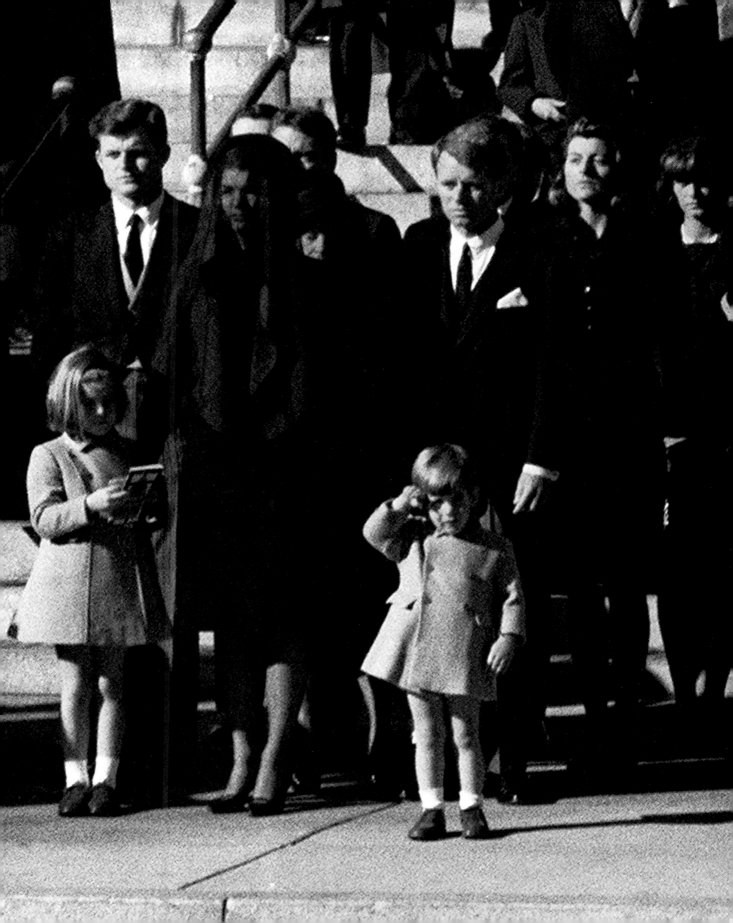

On December 6, Jackie and the children moved out of the White House and into Undersecretary of State Averell Harriman's Georgetown home, which the Harrimans lent to Jackie until she could find a home to purchase. (Jackie apparently preferred not to live on the Kennedy compound in Hyannis Port.)

The day after the move, John and Caroline frolicked in a park near their new residence. While Caroline sometimes seemed her old carefree self, many noticed that she now was given to periods of moodiness and melancholy.

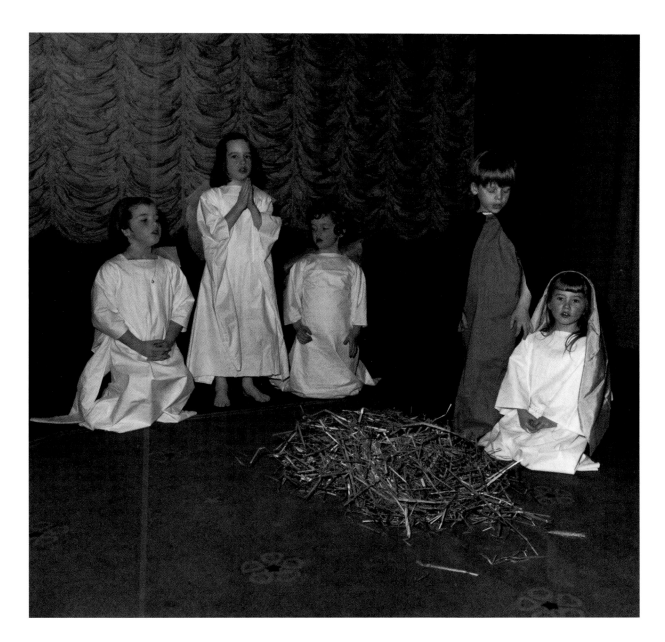

Caroline (*left*) participates in a Christmas play in the White House on December 16. She continued to attend school in the mansion until the Christmas break. That proved the last time she would set foot in the White House until February 1971, when President Nixon invited Jackie and the children to a private viewing of the Kennedys' official portraits. Jackie had declined an invitation to the public unveiling, writing to Nixon, "I really do not have the courage to . . . bring the children back to the only home they both knew with their father under such traumatic conditions. With the press and everything, something I try to avoid in their little lives."

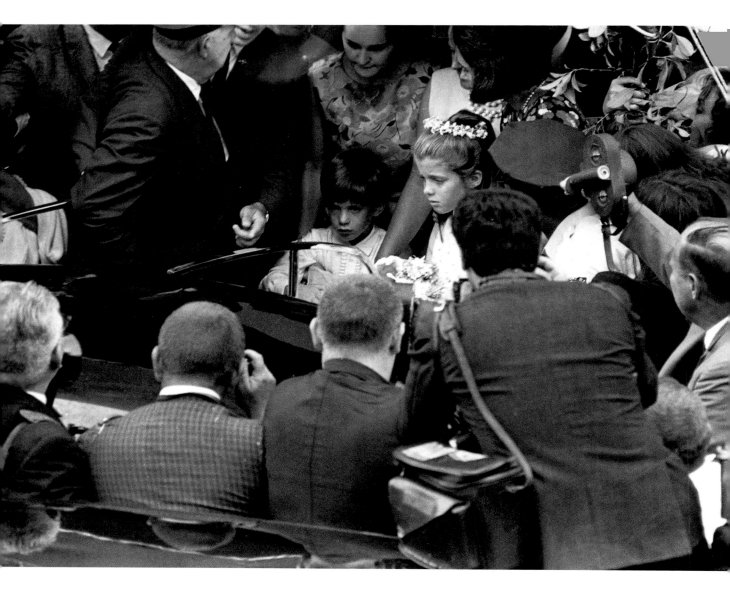

Reporters, photographers, and celebrity watchers mob John and Caroline as they emerge from the wedding of their aunt Janet Auchincloss to Lewis P. Rutherford in Newport, Rhode Island, on July 30, 1966.

1964–1968

"Morning, noon, and night the street was clogged with people peering in at [Jackie] and the children. . . . It [became] a nightmare."
—FRANKLIN ROOSEVELT JR.

❧

"Why did Jack have to die so young? . . . It's so hard for the children."
—JACKIE KENNEDY

❧

"If they're killing Kennedys, my kids are the number-one targets."
—JACKIE, after the assassination of Bobby Kennedy

Their way of life had been wrenched from them almost as quickly as their father had been. Gone were Daddy's games and stories, the flights on Air Force One, the visiting dignitaries and military salutes, the high jinks in the Oval Office. Gone, too, were the myriad rooms to play in, the horses and dogs and birds and hamsters, the staff members who delighted in delighting the children. Now, as John said succinctly many years later, there was "just the three of us—Caroline, Mommy, and me." At her sixth birthday party, held days after her father's funeral, Caroline was asked to make a wish. "I want to see my daddy again," she replied softly.

Their uncle Bobby tried to be a surrogate father, but he had eight children of his own and a new career as a Senator from New York. Their mother worked to make their lives as full—and as normal—as possible, often against daunting odds. They had to move from their townhouse in Georgetown to the relative anonymity of a high-rise apartment in New York City because of the constant hordes of photographers and gawkers who milled outside and often attempted to see into their lives through the curtains.

They traveled across America and the world—Hawaii, England, Switzerland, Argentina, and Ireland. When the unthinkable happened and another bullet pierced a Kennedy skull, Jackie married a Greek tycoon, partly to give her children the protection a private island in the Aegean Sea would provide them. Their mother's remarriage also gave John and Caroline still another rarefied new life.

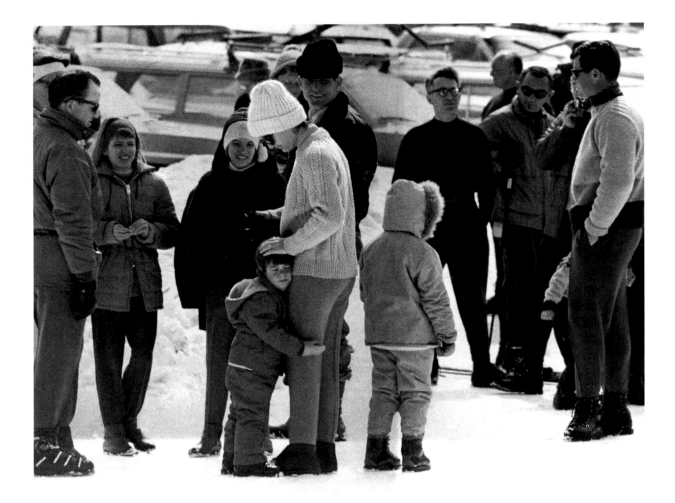

ABOVE March 1964: Three-year-old John hugs his mother for moral support just before trying his hand at skiing for the first time during a winter vacation at Mt. Mansfield in Stowe, Vermont. Caroline turns to look at her uncle Ted (*far right*). After a few falls and some tears, John got the knack of the sport.

A few months earlier, both Caroline and John had been stricken with chicken pox. Caroline was a model patient, but John would not stay confined to his bed when Miss Shaw wasn't around. "It was so funny," she recalled, "because I used to go out of the room and wait outside his door, knowing full well what he was going to do. I would hear his little feet padding across the bedroom carpet, the door would open ever so slowly, and then his head popped round the door, his face bright with mischief."

OPPOSITE Crowds of well-wishers mob Jackie and six-year-old Caroline as they visit the World's Fair in New York, May 1, 1964. Caroline is missing her two front baby teeth.

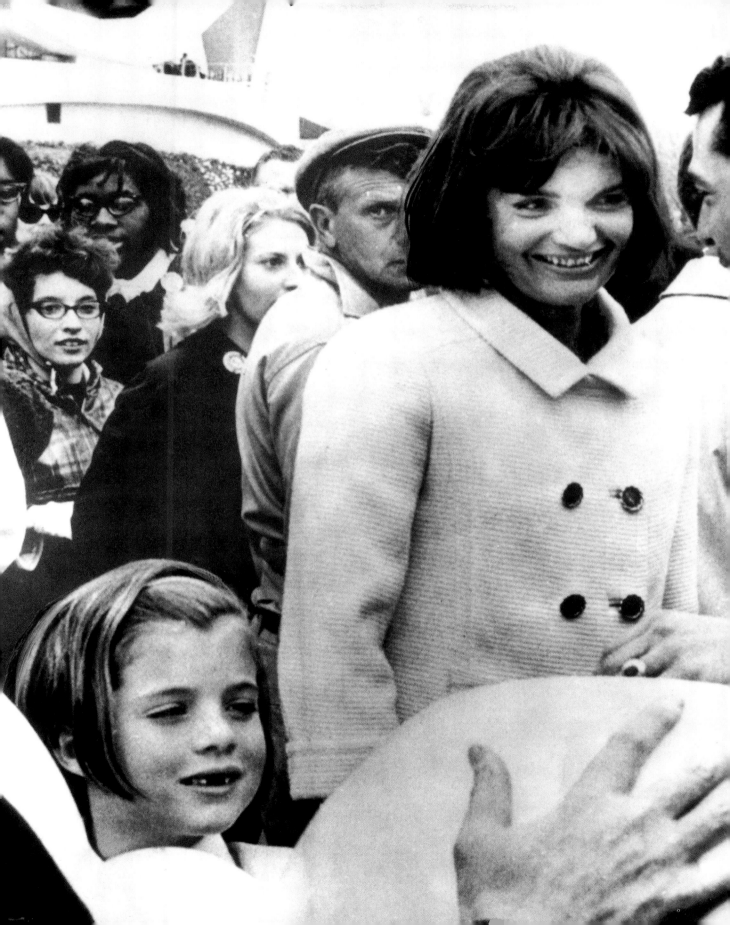

RIGHT May 29, 1964: Caroline slips a small pin from John's coat as they and their mother visit John F. Kennedy's grave on what would have been his forty-seventh birthday. John left the pin on the grave as a token of love.

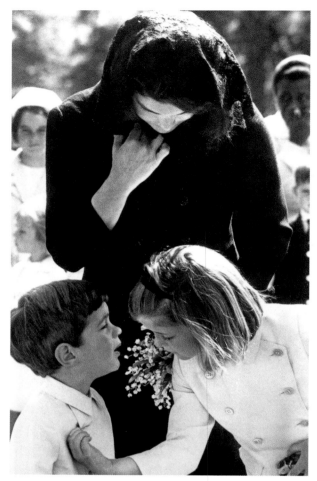

BELOW In September 1964, Jackie purchased a fifteen-room co-op apartment at 1040 Fifth Avenue in Manhattan, overlooking the Metropolitan Museum. She felt the city would afford her and the children more anonymity than they had had in Georgetown (an assumption that would prove largely untrue), and she wanted the children to enjoy the rich cultural life of New York, just as she had as a girl.

On September 15, Jackie took Caroline to her new school, the Convent of the Sacred Heart on East Ninety-first Street, and then brought John to visit his uncle Bobby's senatorial campaign headquarters. At the end of the day, mother and children took a boat ride on a lake in Central Park. As always, Secret Service agents were nearby; they were also stationed outside Caroline's classroom and often escorted her to and from school.

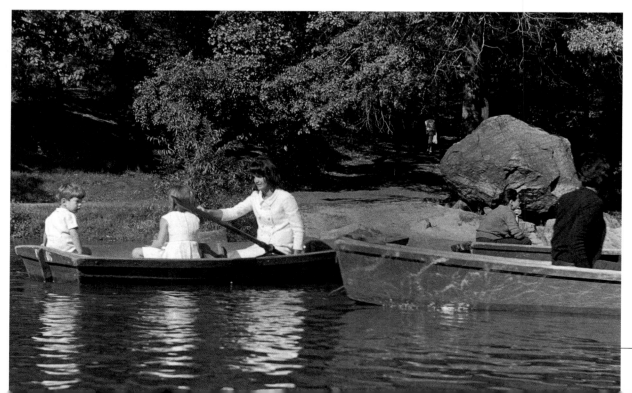

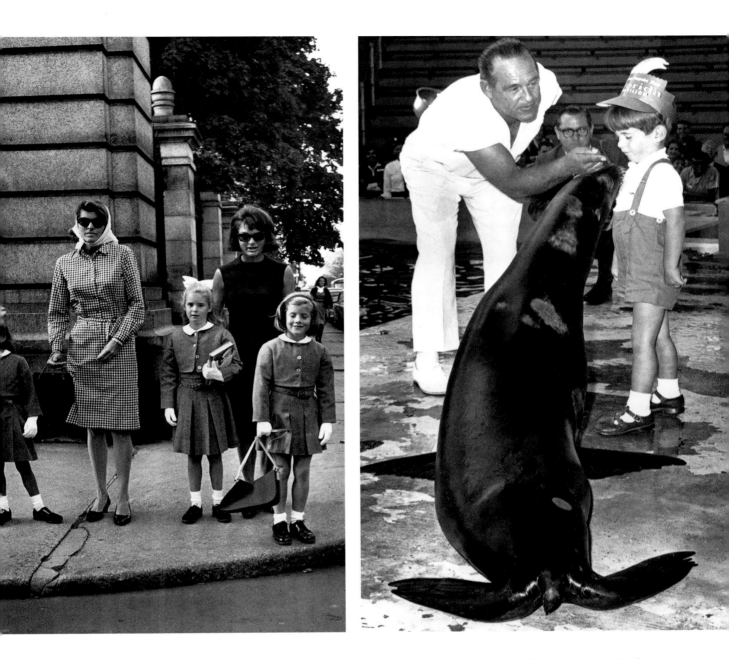

ABOVE LEFT The next day, Jackie walks Caroline to school along with Pat Lawford and her daughters, Sydney (*center*) and Victoria, also enrolled in Caroline's school. Sydney, just turned eight, and Caroline, soon to be seven, became close friends throughout their lives, "more like sisters than cousins," Maud Shaw felt.

Caroline proved an excellent student, winning A's consistently and gold medals in deportment and French.

ABOVE RIGHT Trainer Dick Berg introduces John to Ronnie the Seal at the Florida Pavilion of the World's Fair on September 21. This was John's first visit to the fair. Two Pinkerton guards, two Secret Service men, and the Reverend Richard McSorley, a family friend, accompanied him.

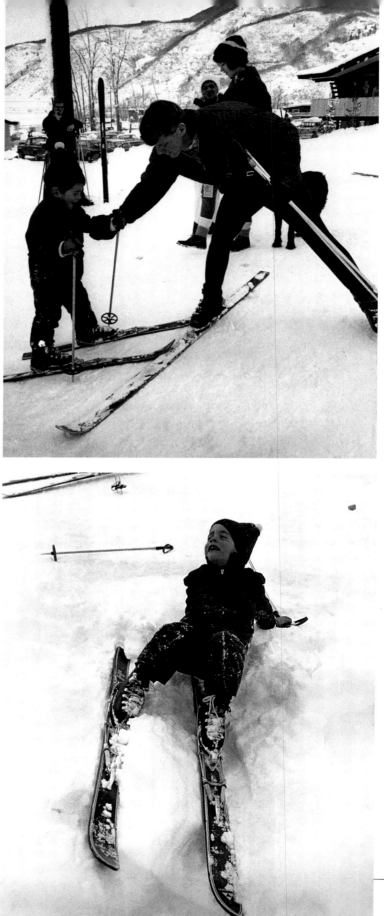

More confident on the slopes now, John gets a little help from his uncle Bobby, the Senator-elect from New York, during a ski trip to Aspen, Colorado, on December 31, 1964. John skied down a fifty-foot run, but like many inexperienced skiers, had a little trouble stopping . . .

. . . and landed on his back in a mound of soft snow at the bottom of the hill.

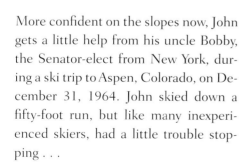

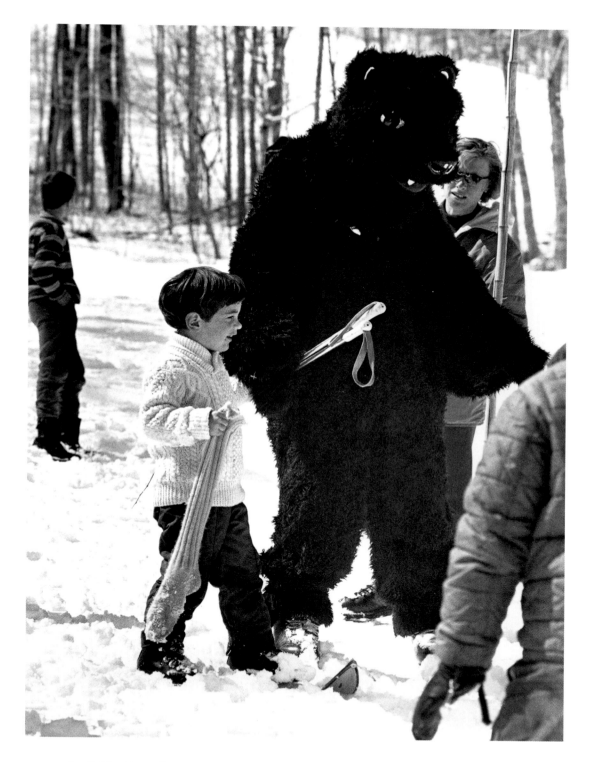

April 18, 1965: During an Easter-costume ski parade at the Stratton Mountain ski area in Vermont, John runs out to greet a "bear." A Secret Service agent soon whisked him away to avoid a collision with another costumed skier.

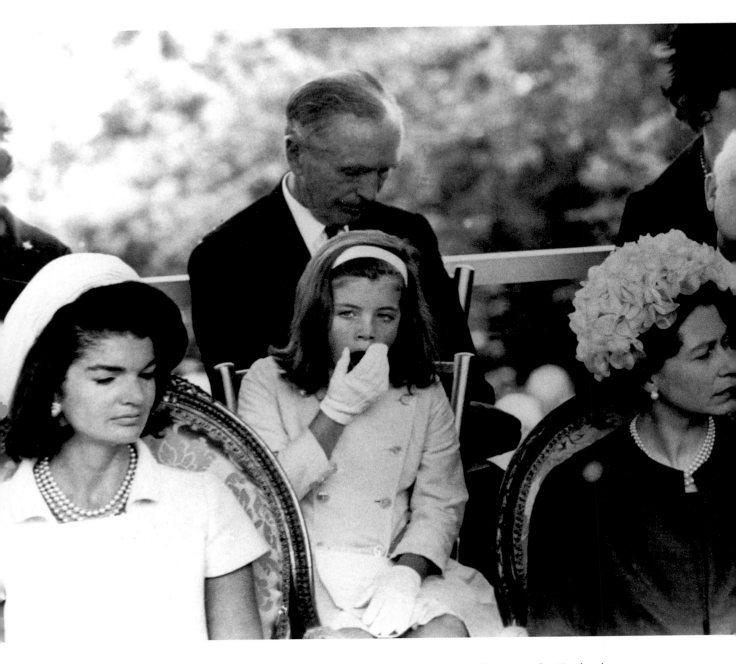

Caroline is unable to stifle a yawn during a ceremony in Runnymede, England, during the dedication of a memorial to her father in May. Flanking her are her mother and Queen Elizabeth.

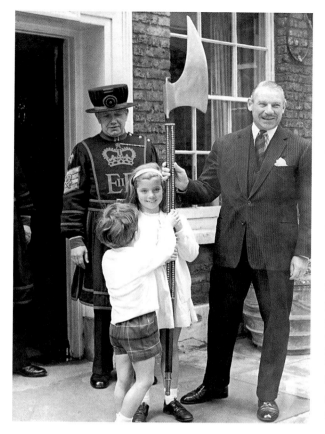

LEFT John and Caroline immensely enjoyed their first visit to England. On May 17 they visited the Tower of London; here they inspect an executioner's axe shown them by Sir Thomas Butler, the Tower's governor. Behind them in Beefeater costume is Chief Warder of the Guard George Arnold. John's fascination with beheadings proved unbounded. He wanted to know where the block was, where the executioner stood, how people placed their heads on the block—"all the gory details," as Maud Shaw recalled.

BELOW The Tower's cannon also held great interest for John. Here Yeoman Jailer Alfred Hinds explains the history of the cannon and its operation and shows John one of the cannonballs. Moments later, John hopped inside the cannon barrel. Caroline had demurred from doing so herself, finding the gun's insides "a bit dirty." She was far more intrigued by the Crown Jewels, which are kept in the Tower.

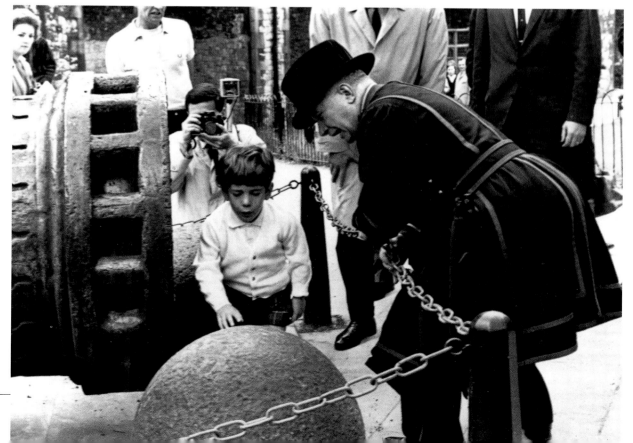

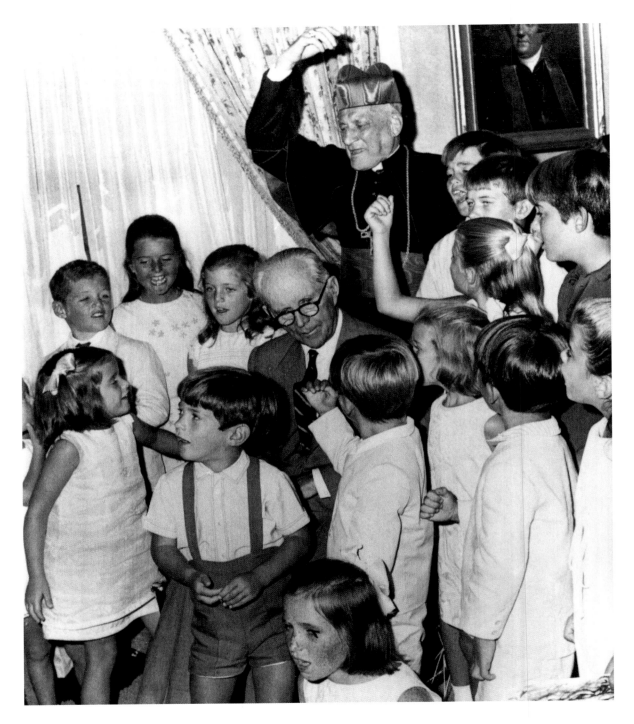

John and Caroline stand next to their grandfather Joseph Kennedy as they and fifteen of their cousins honor Boston's Richard Cardinal Cushing on his seventieth birthday, August 24, 1965. The humorist Art Buchwald once said, "All Kennedy children look alike. Do not ask your host or hostess which child belongs to which family. Nobody knows and it will only embarrass them."

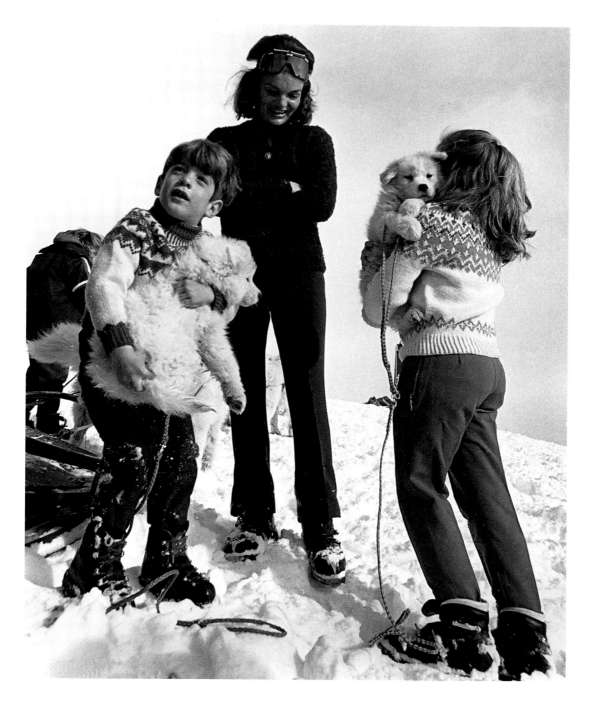

Yet another skiing trip, to Sun Valley, Idaho, in December. By now John was proficient on skis, as was Caroline, whose enthusiasm for physical pursuits nearly matched her brother's. Jackie Kennedy took her first skiing lesson during this vacation. Here John and Caroline carry Samoyed puppies they befriended when the pups turned up at the restaurant halfway up Mt. Baldy. The Samoyeds are used as sled dogs in Sun Valley.

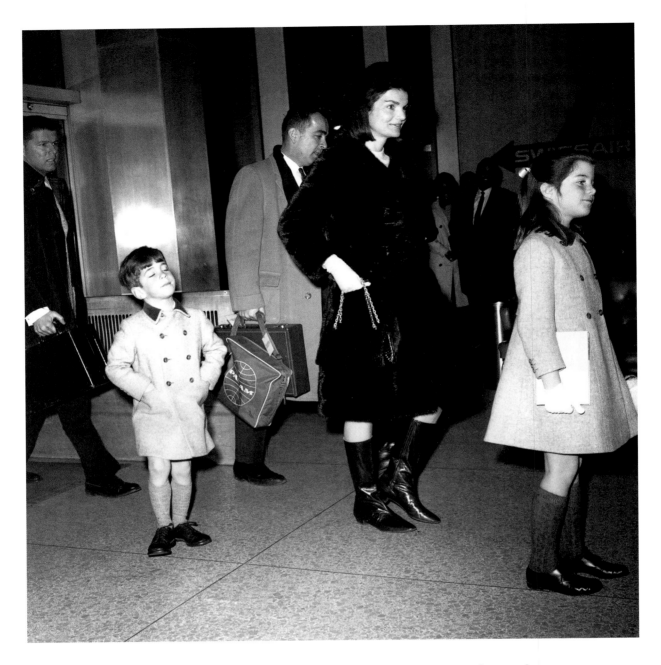

At New York's John F. Kennedy Airport on January 15, 1966, a reflection from a photographer's speed light creates a halo effect over John's head as he hams it up for the camera. The family once again embarked on a skiing trip, this one to Gstaad, Switzerland. The frequent trips were a way to allay Jackie's—and the children's—feelings of loss, and were also part of Jackie's determination to show her children as much of the world as possible.

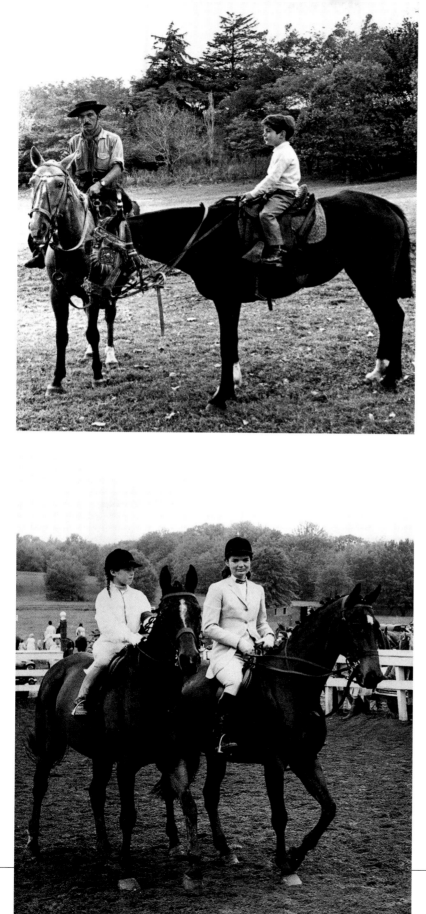

TOP April 7, 1966: A gaucho escorts John around the grounds of the isolated Carcano ranch in Ascochinga, Cordoba Province, Argentina. The Kennedys were the guest of Argentina's foreign minister, Miguel A. Carcano. The remoteness of the property didn't prevent reporters and paparazzi from stalking the former First Family. When five-year-old John doffed his clothes to swim in a nearby stream, headlines screamed, JFK JR. TAKES DIP IN THE NUDE.

BOTTOM While her brother never took much to horseback riding, Caroline became an accomplished horsewoman. Here she and Jackie ride in the annual horse show at St. John's Church, New Vernon, New Jersey, near their vacation farmhouse in Bernardsville. Mother and daughter took second place in the family event, held on May 28.

TOP On June 11, the three traveling Kennedys were in Hawaii on a seven-week vacation with Patricia Kennedy's former husband, Peter Lawford, and two of his children. Here Jackie admonishes a rambunctious John to quiet down during a visit to the state capitol, Iolani Palace.

Peter Lawford had spent a great deal of time in Hawaii as a youth and young man, so he was able to show Jackie and the children the best the islands had to offer. Still, John's happiest times were had with three local brothers he befriended, ages eleven to fourteen. "You would think we'd get annoyed with a little five-year-old tagging along," one of the boys, Tommy Miske, said. "But we found him to be a fun and adventuresome little kid. We slid down mudslides in Nuuanu. We hiked through huge boulders at Sacred Falls . . . Caroline got coral cuts that had to be bandaged."

BOTTOM John, too, was injured in Hawaii when he fell into a cooking pit at a luau on the big island of Hawaii. He burned his buttocks and right arm and hand, and was saved from worse injuries by a quick-acting Secret Service agent, John Walsh, who pulled him from the pit. John was rushed to a hospital, treated, and released two hours later. During their stopover in Los Angeles on their way back to New York on July 25, John wore a white glove to protect his hand, which was covered with second-degree burns, from infection.

July 30: A fellow page at the Hammersmith Farm wedding of Jackie's half-sister Janet Auchincloss restrains an angry John from fighting with a boy who had called him a "sissy" because of his white satin and blue sash page's outfit. Later, though, John tussled in the dirt with another boy who offended him, then attempted to lead two of the Auchincloss ponies through the reception tent. John's uncle Jamie Auchincloss found John's behavior charming. "John was not being bratty," he said. "It was just that he didn't like wearing pale blue silk and satin and having his hair combed all the time. He liked to clown around in a nice way." Another guest at the wedding wasn't amused. "That boy travels at ninety miles an hour," she sniffed, "at right angles to everyone else."

RIGHT On August 12, 1966, Caroline and seven of her cousins visited the war memorial USS *Massachusetts* in Fall River, Massachusetts. During lunch, a waitress asked her to autograph one of the place mats. Caroline obliged.

BELOW Jackie and baseball fan John, now six, attend the New York Yankees' season opener at Yankee Stadium on April 14, 1967. The home team lost to the Boston Red Sox, 3–0, when rookie Bill Rohr pitched eight and two-thirds innings of no-hit baseball. The Red Sox would go on to win the American League pennant on the last day of the season.

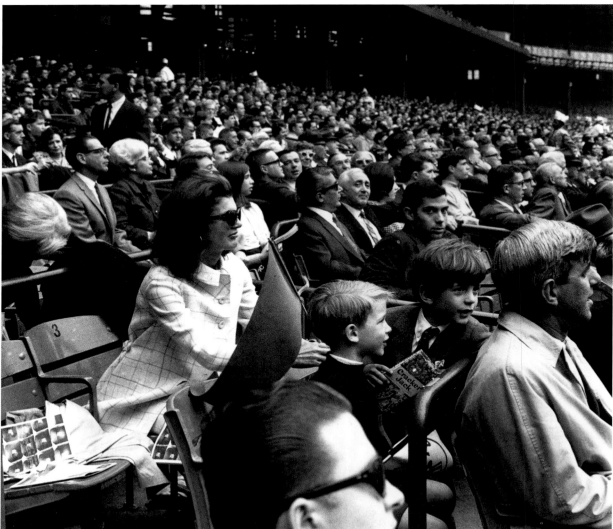

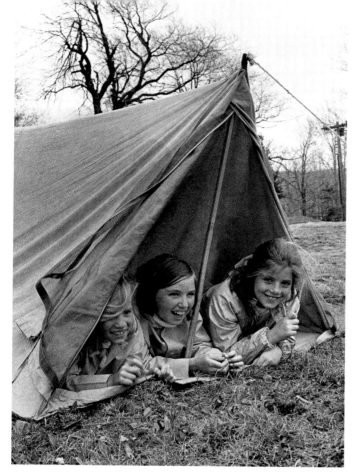

LEFT Caroline, ten, and her cousins Courtney (*center*) and Kerry Kennedy peer out from their tent during a river rafting trip with Robert Kennedy at North Creek, New York, in May. It was at times like this—vacations and holidays—when Bobby Kennedy was best able to be a substitute father to John and Caroline.

BELOW Courtney seems terrified as Caroline paddles along with a guide during a whitewater derby canoe race on May 7.

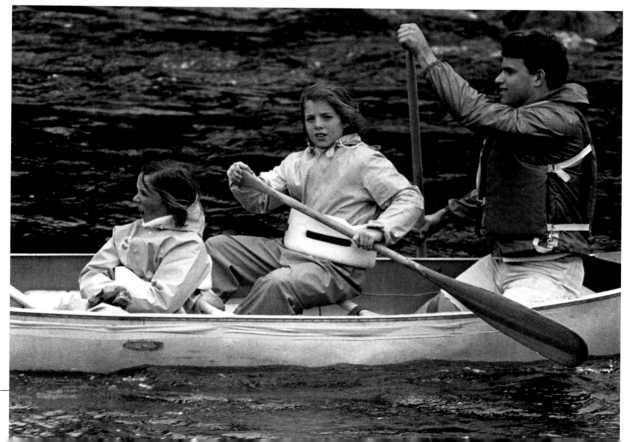

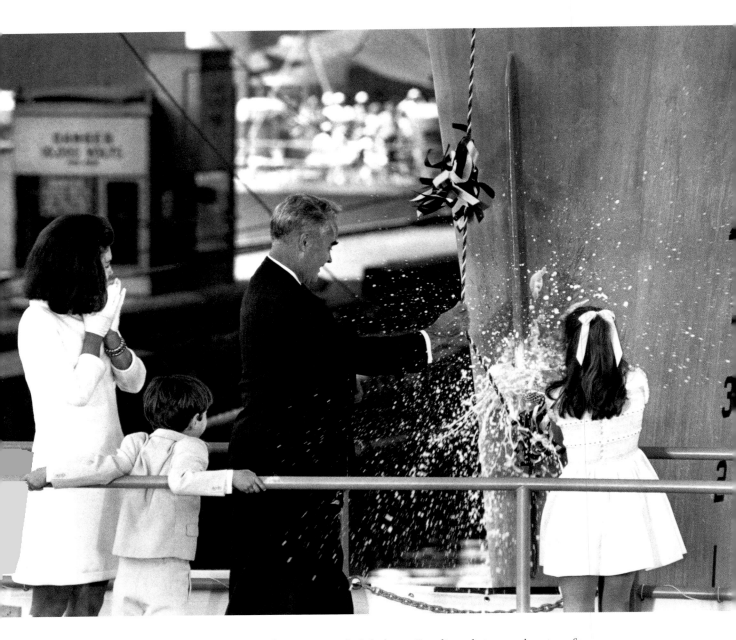

Three weeks later, Jackie reacts with delight as Caroline christens the aircraft carrier USS *John F. Kennedy* at Newport News, Virginia. In the center is Donald A. Holden, president of the company that built the huge craft. Both John and Caroline took great pride in their father's legacy. For years after his death, Caroline clipped photographs of him out of newspapers and magazines and tacked them to her bedroom walls. And John would almost invariably play LP records of JFK's speeches when friends came over to play.

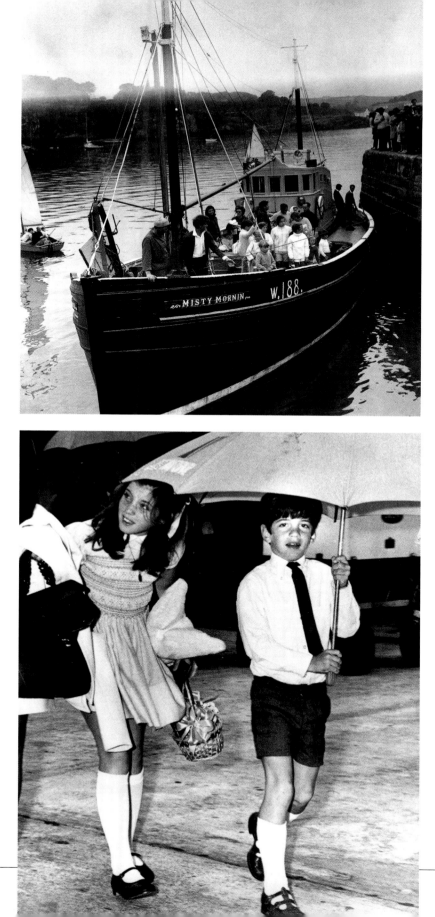

TOP In late June Jackie and the children took their first trip to Ireland, John F. Kennedy's ancestral homeland. The Irish people warmly embraced the family of the man who had become a national hero to them, and photographs of the Kennedys adorned the covers of Irish newspapers every day of their month-long stay. On a bus ride to Dublin, John sang the Irish folk songs "Sweet Rosie O'Grady" and "When Irish Eyes Are Smiling." The bus driver, whose name was John F. Kennedy, said, "He has a grand voice and he knew all the names."

Caroline went swimming at Waterford, but John preferred to visit a candy store, where he announced he wanted "everything."

BOTTOM A chivalrous John carries an umbrella as he and Caroline leave Palm Beach after an Easter holiday, April 15, 1968. Caroline carries a large stuffed bunny and Easter basket.

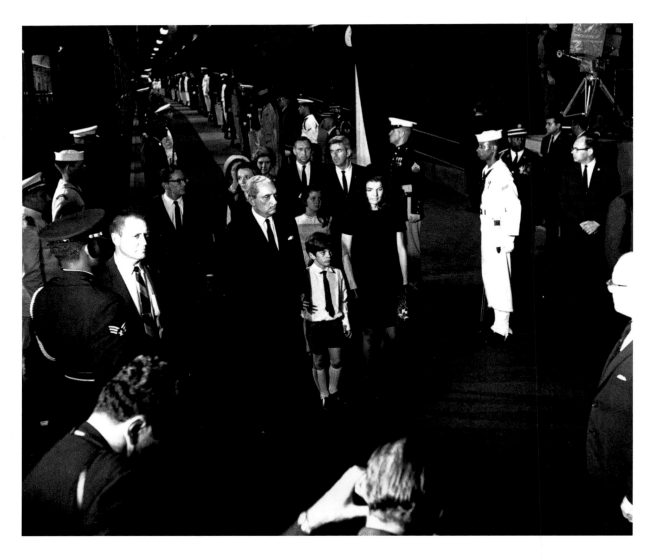

Another horrific tragedy for the Kennedys and the country: On June 4, 1968, shortly after proclaiming victory in the California Democratic Presidential primary, Robert Kennedy was shot in the head. He died two days later. On June 8, hundreds of thousands of people filed past Bobby's coffin in St. Patrick's Cathedral. Then the invited mourners boarded a train for his burial in Arlington National Cemetery. Two million people lined the train's route in tribute to Kennedy. In this photograph, Jackie, John, and Prince Radziwill lead the way off the train, followed by Lee Radziwill, Caroline, and other mourners.

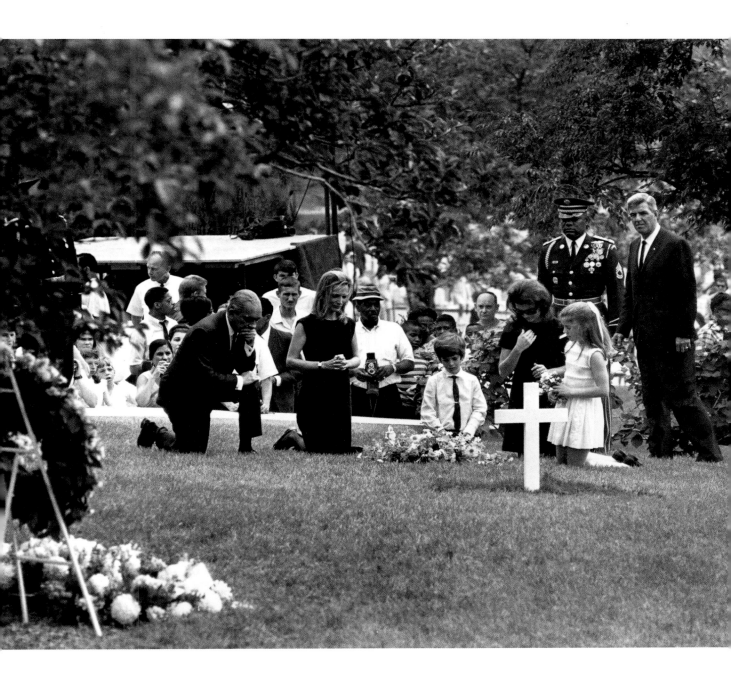

The Kennedys and Radziwills pray over Bobby's grave the next day. Jackie was so shattered by Bobby's murder that she directed her anger at the climate of hate that seemed to have gripped the United States. (Martin Luther King Jr. had been slain just two months before Bobby.) "I hate this country!" she said privately. "If they are killing Kennedys, my kids are the number-one targets. I want to get out of this country!" Within a few months, she and her children would indeed leave America—at least for part of the time.

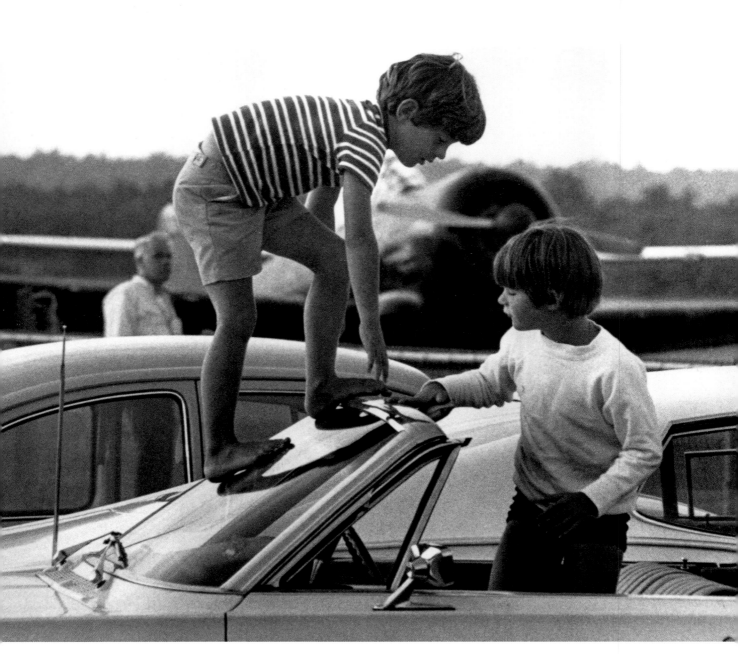

Boisterous as usual, John clambers across the windshield of a car at Hyannis Airport while he awaits his mother's return from a vacation in the Greek isles with Aristotle Onassis, the man she would soon marry. With John is a cousin.

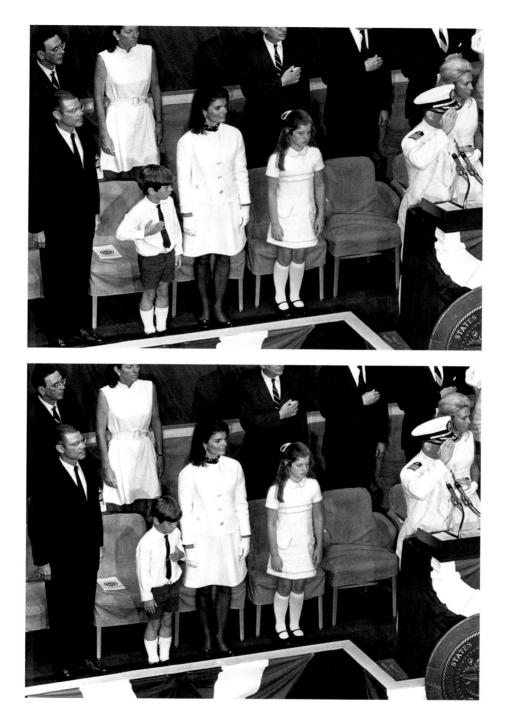

John can't seem to make up his mind which hand to place over his heart (or which side his heart is on) during the playing of the National Anthem at the commissioning ceremonies for the USS *John F. Kennedy* in Newport News on September 17, 1968. He began with his right hand, then used both, and ended up with his left hand over his heart.

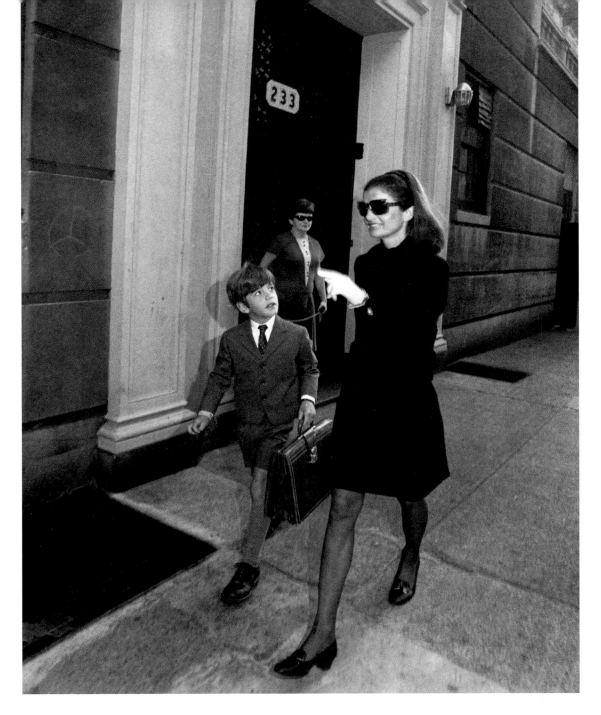

Jackie escorts John, nearly eight, to his first day of third grade at the Collegiate School on West Seventy-seventh Street in Manhattan on September 20. Jackie had transferred John from St. David's, a Catholic school on East Sixty-ninth Street, which he had attended since February 1965. As he had at St. David's, John made friends quickly but also got into fistfights with boys who taunted him. Some of his tormenters were particularly cruel; one boy at St. David's had called after Jackie and John as they left the school on November 22, 1966, "Your father's dead! Your father's dead!" Rather than retaliate, John simply squeezed his mother's hand, "as if he were trying to reassure me," Jackie said, "that things were all right."

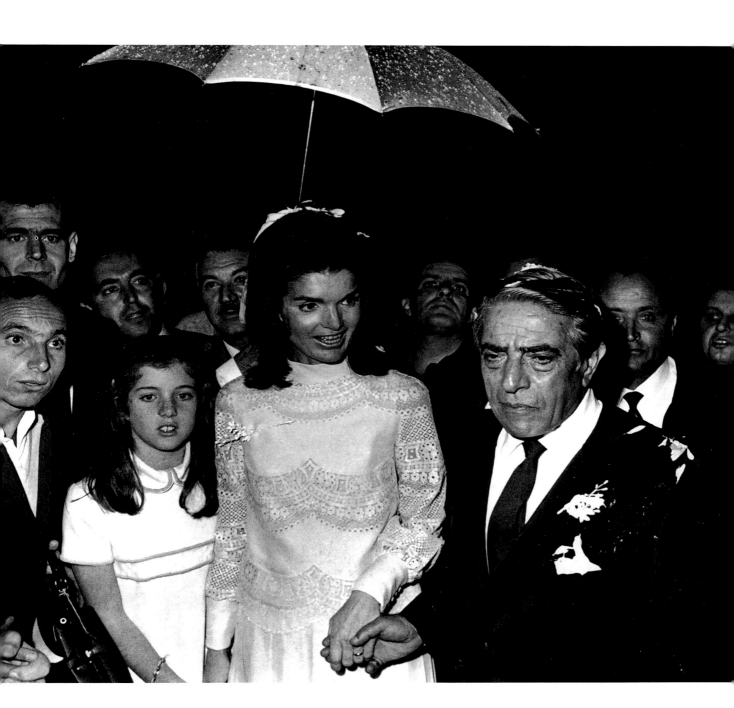

On October 20, Jacqueline Kennedy married Aristotle Onassis, nearly twenty-five years her senior. John and Caroline attended the wedding in a small chapel on Skorpios, Onassis's 350-acre island off the coast of Greece. Although many Americans abhorred Jackie's decision to marry the gruff, squat shipping tycoon, Jackie responded to Ari's warmth and joie de vivre, and loved him for the special attention he showered on both her children, while all the time assuring them that he in no way meant to replace their father.

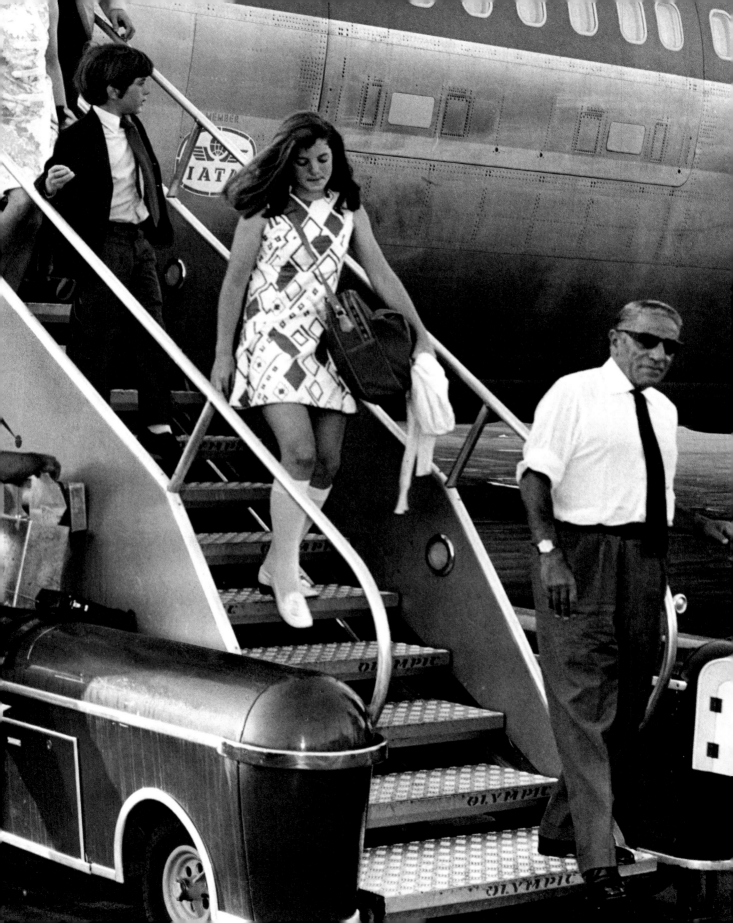

1969–1975

"Don't forget, John, we will always be filaracos.*"*

—ARISTOTLE ONASSIS to eight-year-old John, using the Greek word for *buddies*

❧

"I just hope he isn't spending all their time together telling
John how to get a woman."

—JACKIE ONASSIS to her husband's secretary

❧

"He was a very dynamic person, a source of refuge and protection for [Jackie]
and her children. I think she felt safe with him, and after 1968
she had been fearful for their safety."

—EDWARD M. KENNEDY on Onassis

OPPOSITE John and Caroline follow Aristotle Onassis down the ramp of an Olympic Airways jet as they arrive in Greece for a summer holiday in 1970.

"Aristotle Onassis was the only father I ever knew," John said years after his stepfather's death. John got along well with Onassis; the shipping tycoon took him on fishing expeditions and long walks during which he dispensed advice to the boy. He showered both his stepchildren with lavish gifts—a speedboat, Jeep, and jukebox for John, a sailboat and ponies for Caroline—but he never formed the same close relationship with Caroline that he did with John. When a classmate asked Caroline what she thought of her stepfather, she replied, "Well, he's away a lot of the time."

John and Caroline lived more rarefied lives than ever now. They cruised on the opulent Onassis yacht Christina, waited on by its sixty-member crew; shopped in Paris and Rome, swam and sailed off Skorpios. Their mother's insistence that they remain humble, polite, and grateful for all that life had given them kept them from turning into the spoiled brats that many far less privileged children become.

They divided their time between Europe and New York City, where they went to school and where their mother made sure they soaked up the cultural riches the city offered. By the time Onassis died in 1975, Caroline had become a self-possessed young woman poised to graduate with honors from Concord Academy. John, still rambunctious and a bit of a bad boy, had a year to go before boarding at Phillips Academy in Andover, Massachusetts. The children of Jacqueline Kennedy Onassis, citizens of the world, would now settle down as full-time residents of the United States.

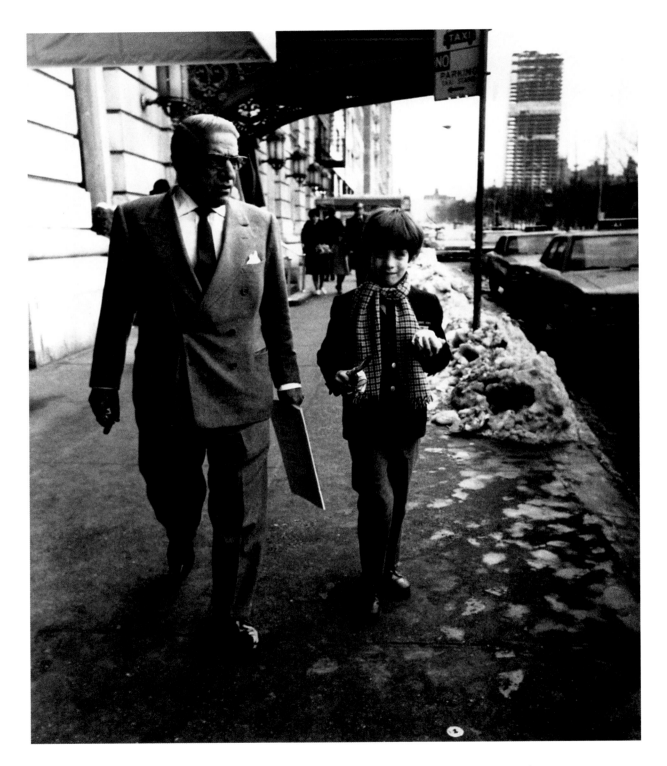

Eight-year-old John and his stepfather leave Trader Vic's restaurant in Manhattan on February 16, 1969. Onassis carries what looks like a menu. John's scarf and miniature canoe paddles were a gift from one of the restaurant's hostesses.

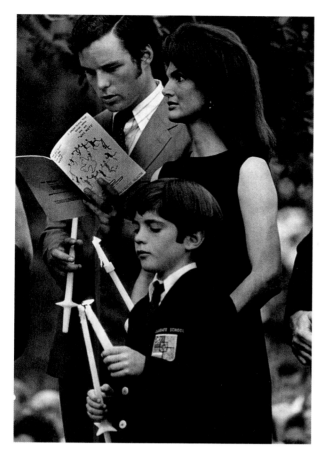

LEFT On June 6, John and his mother carry candles at a memorial service at Arlington National Cemetery for Robert Kennedy on the first anniversary of his death.

BELOW The next day, Caroline seems perturbed at having her picture taken showing a new set of braces. She was attending the dedication ceremonies for Robert F. Kennedy Stadium in Washington, D.C.

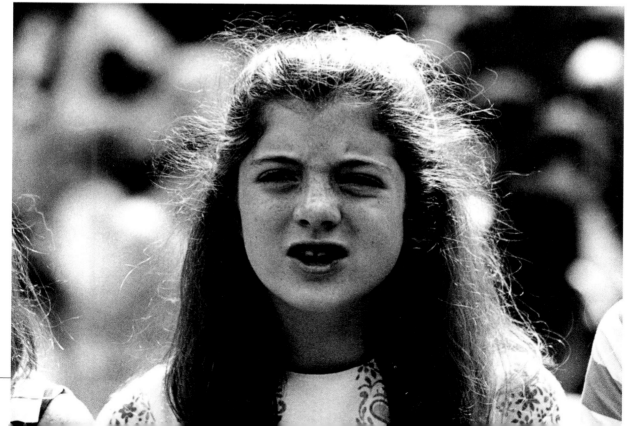

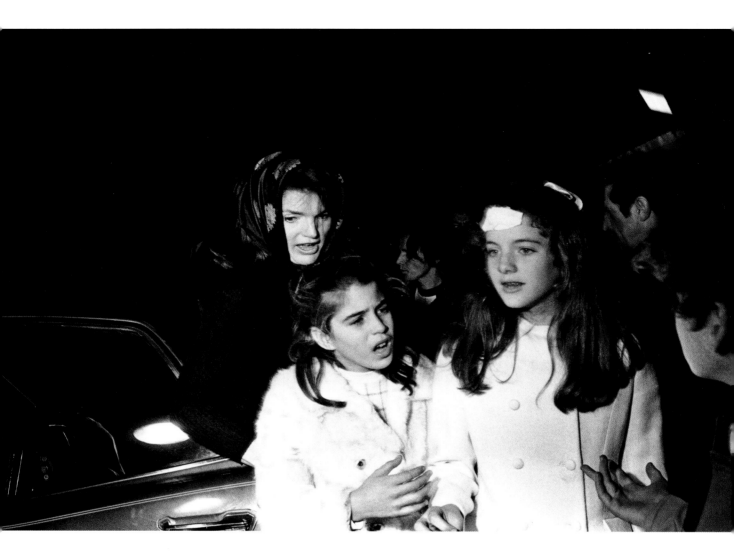

Hyannis Port, November 21, 1969. Jackie, Caroline (her forehead bandaged after a fall), and cousin Victoria Lawford arrive for the funeral of Joseph Kennedy, who had died three days earlier at the age of eighty-one after years of incapacitation following a stroke. John recited the Twenty-third Psalm at the funeral Mass.

LEFT Jackie and the children spent Christmas 1969 in England with the Radziwills at their Queen Anne mansion in the Berkshire Hills. They posed for photographers with Christina Radziwill while foraging the grounds of the estate for boughs to decorate the Christmas tree.

BELOW April 3, 1970: On Skorpios, John steers the motorboat named after him as he and his mother leave the island to board the Onassis yacht *Christina,* named after Ari's daughter.

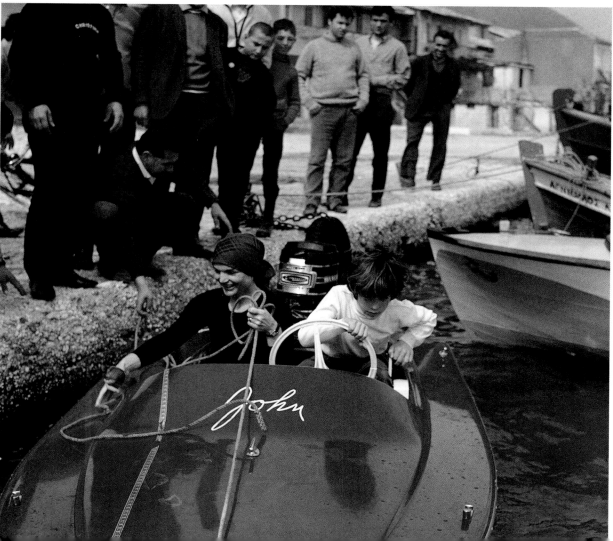

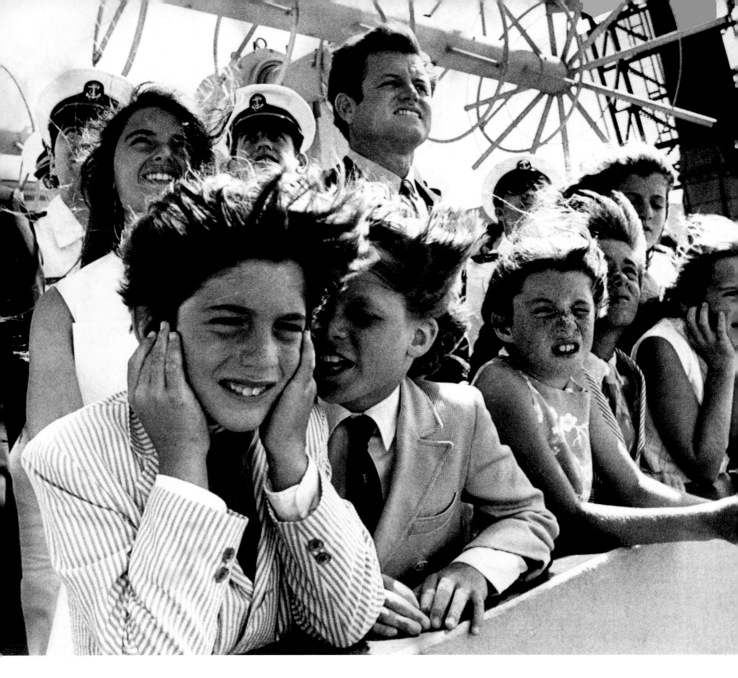

John plugs his ears against blasting horns and whipping winds onboard the USS *John F. Kennedy*, making its first visit to Boston in August 1970. Behind John is Maria Shriver, and next to him Ted Kennedy Jr., whose father stands next to Maria. Caroline is second from the right in this picture, amid several other cousins.

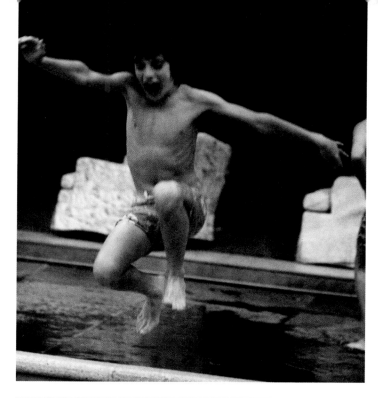

TOP John jumps into a pool at Hyannis Port in the summer of 1970. The boy continued to love the water, and had been a proficient swimmer from an early age.

BOTTOM During a Mediterranean cruise aboard the *Christina* in June 1971, Caroline, thirteen, and her mother visited Portofino, Italy, where they shopped and went sightseeing. One of Caroline's cousins described the relationship between Jackie and Caroline as "terribly close. Watching the two of them together, talking, gossiping, with their heads together discussing some problem, it's more like watching two sisters. . . . It's not at all the same with John. John can be irritating, and Jackie gets irked with him. But not with Caroline. They're like one soul."

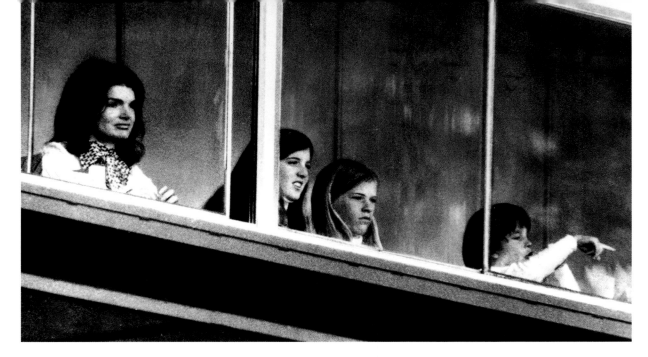

ABOVE Jackie, Caroline, Victoria Lawford, and John take in a football game at Yankee Stadium between the New York Giants and Baltimore Colts on October 17, 1971.

RIGHT Also in October, this issue of *Photo Screen* magazine appeared on the newsstand, signaling to Caroline that now that she was a young lady she was fair game for the silliest "movie magazine" stories, usually fabricated from whole cloth, as was this one.

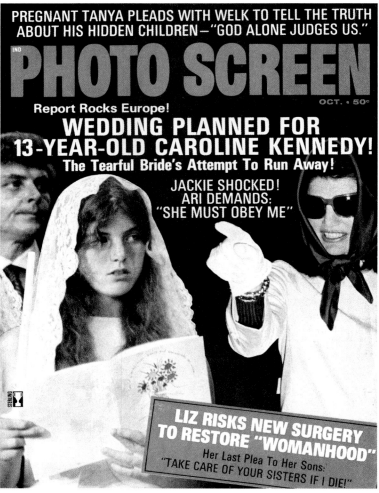

PREGNANT TANYA PLEADS WITH WELK TO TELL THE TRUTH ABOUT HIS HIDDEN CHILDREN—"GOD ALONE JUDGES US."

PHOTO SCREEN

IND

OCT. • 50¢

Report Rocks Europe!

WEDDING PLANNED FOR 13-YEAR-OLD CAROLINE KENNEDY!
The Tearful Bride's Attempt To Run Away!

JACKIE SHOCKED!
ARI DEMANDS:
"SHE MUST OBEY ME"

LIZ RISKS NEW SURGERY TO RESTORE "WOMANHOOD"
Her Last Plea To Her Sons:
"TAKE CARE OF YOUR SISTERS IF I DIE!"

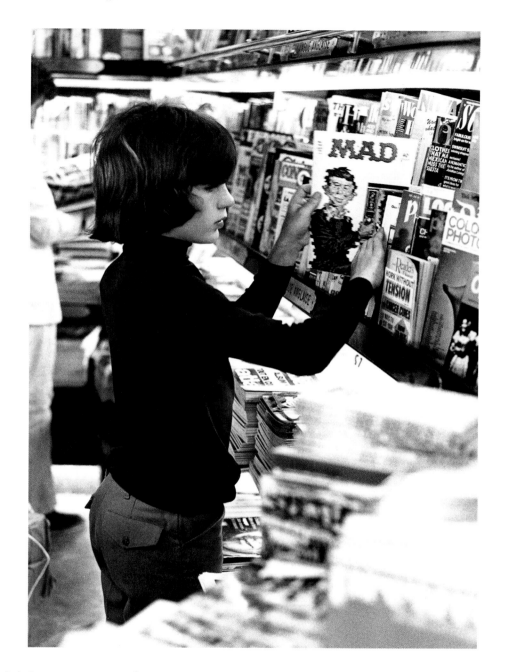

In the English-language section of a Paris newsstand, nine-year-old John picks up his favorite magazine in the spring of 1972. The family often spent time at Onassis's Avenue Foch apartment in the French capital.

While most observers credited both John and Caroline with being "good kids," neither was immune from the occasional display of willfulness. Caroline had been known to attempt to forge to the head of a line by saying, "I'm *Caroline Kennedy!*" And John, told by his mother that an item he wanted for Christmas was too expensive, yelled at her, "You're the richest woman in the world and you say it costs too much?!"

It was around this time, too, that Jackie complained to a friend, "Do you have the same problems with your girls as I have with Caroline? She knows everything and I know nothing. I can't do anything with her."

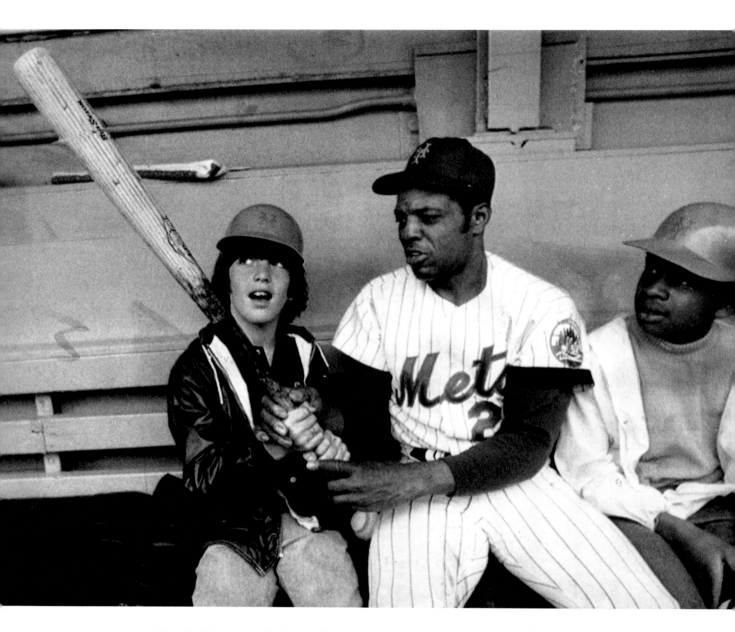

New York Mets outfielder Willie Mays shows John the proper way to hold a base-ball bat as John's friend Eric von Huguley looks on. John and Eric visited the Mets' dugout before a game versus Atlanta at Shea Stadium on June 4, 1972.

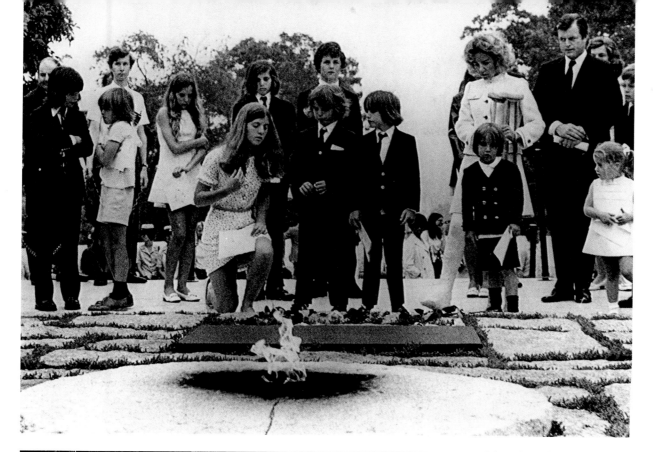

ABOVE Two days later, John (*far left*), Caroline (*kneeling*), and Robert Kennedy's children join Ethel and Ted Kennedy at RFK's grave on the fourth anniversary of his death.

LEFT John leaves to use the restroom during lunch at a café on the Isle of Capri on August 1. The family was once again cruising the Mediterranean aboard the *Christina,* and had just come from a few days on Sardinia's Emerald Coast.

John turns his red-white-and-blue straw boater into a pillbox hat while viewing the action at the first annual Robert F. Kennedy Pro-Celebrity Tennis Tournament at Forest Hills, New York, in August 1972. With him are his cousins William Kennedy Smith (*center*) and Ted Kennedy Jr. The tournament benefits the Special Olympics, a sports program for developmentally challenged children.

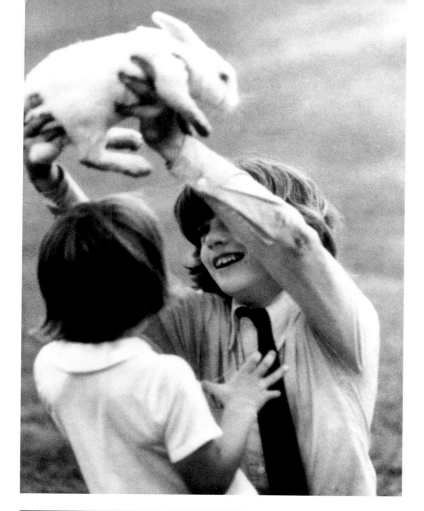

TOP John and one of his cousins play with a rabbit during an Easter holiday at Hickory Hill, the home of Ethel Kennedy, April 1973.

BOTTOM Caroline and her aunt Joan Kennedy beam as they applaud Democratic Presidential nominee George McGovern at a fund-raiser at Boston's Commonwealth Armory on October 12. Despite Kennedy in-law Sargent Shriver's presence on the ticket, McGovern lost soundly to President Richard Nixon.

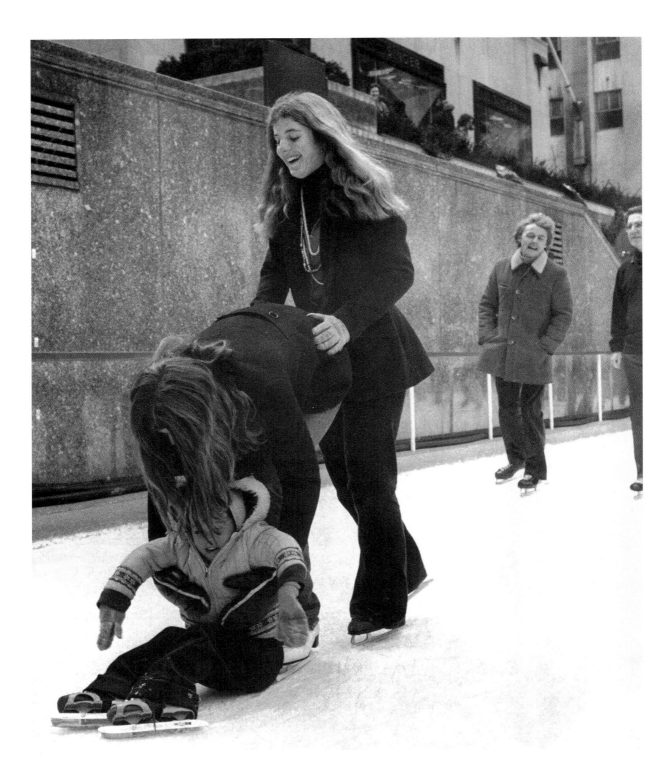

At the ninth annual Robert F. Kennedy skating breakfast at New York's Rockefeller Center skating rink, Caroline and her cousin Victoria Lawford assist a fallen child. One hundred fifty children from a Bedford-Stuyvesant community program were invited to participate in the event, held December 15.

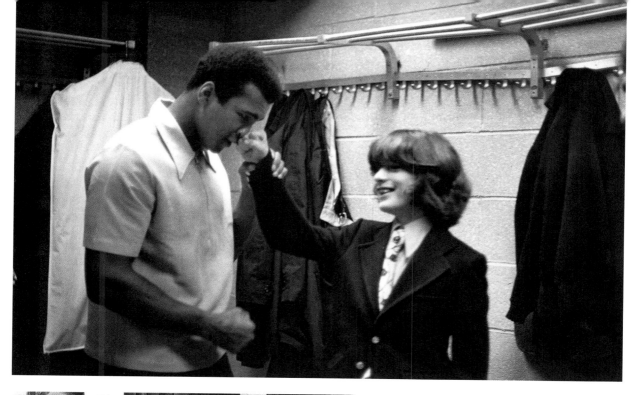

ABOVE John clowns around with one of his idols, Muhammad Ali, prior to his bout with Joe Frazier in New York, January 28, 1974. Ali won a unanimous twelve-round decision.

LEFT John and Caroline seem bored as they listen to energy hearings conducted by Senator Ted Kennedy in the John F. Kennedy Federal Building in Boston, February 23, 1974.

Her mother had become a little concerned about Caroline's weight. (Jackie and her sister, Lee, obviously subscribed to the dictum that one "can never be too rich or too thin.") She urged Caroline to take ballet lessons as a form of exercise, but "she just wasn't interested," Jackie said. A friend of Jackie's felt sorry for Caroline, who craved burgers and French fries and had little interest in haute couture. "It must have been hard to be the daughter of a svelte, beautiful, stylish woman like Jackie, to be compared to that incredible standard Jackie set."

August 1974: John doesn't seem self-conscious about his new braces as he chats with a cousin during the third annual RFK Tennis Tournament at Forest Hills, New York.

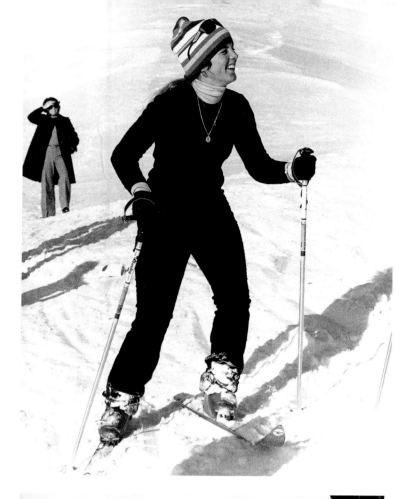

LEFT Caroline takes to the slopes during a ski vacation in Gstaad, Switzerland, January 2, 1975. While she wasn't as sports-minded as her brother, Caroline had developed into a better-than-average athlete.

BELOW Fifteen-year-old John prepares to toss a snowball at a photographer while riding a ski lift near Hancock, Massachusetts, on February 16. "He missed," the cameraman reported with some satisfaction.

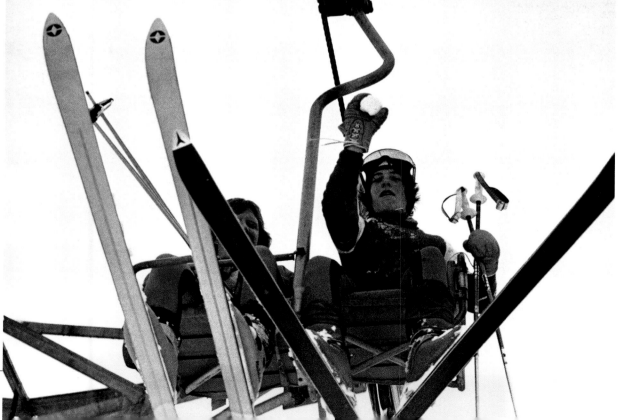

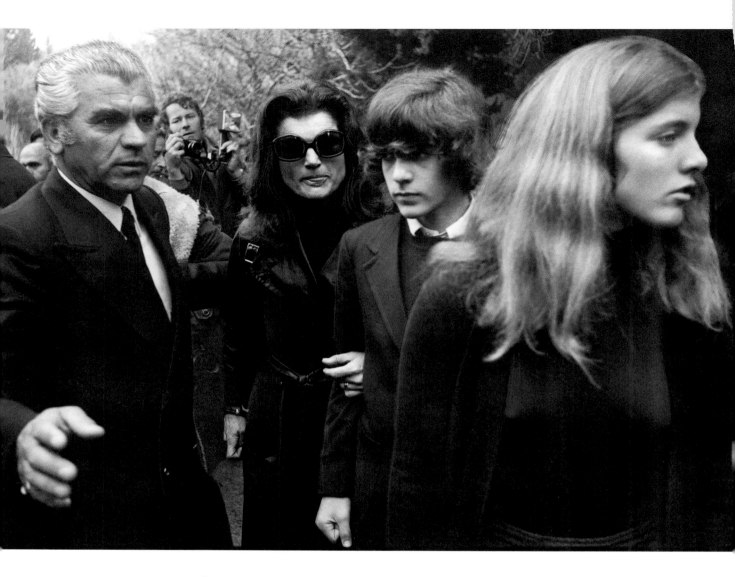

On March 15, 1975, sixty-eight-year-old Aristotle Onassis died in Paris after a series of illnesses. Jackie and the children encountered a mob scene as they left their Fifth Avenue apartment to fly to Greece for the funeral, at which they are pictured here. Jackie and Onassis had been estranged for several years, particularly after the death in a plane crash of Onassis's only son, Alex, which sent Onassis into a tailspin of depression. The warmth and generosity that John and Caroline had enjoyed from their stepfather had been replaced by animosity toward their mother, and neither felt terrible sorrow at his death.

John's bad-boy side comes to the fore again as he bites Maria Shriver's hand during a picture-taking session at the Tretyakov Gallery in Moscow, April 1975. He accompanied his aunt and uncle Eunice and Sargent Shriver and their children on this trip to Russia. The next day, a bored John sailed paper airplanes over the heads of an assemblage listening to Sargent Shriver give a speech.

Seventeen-year-old Caroline doesn't seem the least bit nervous as she waits to join the processional at her graduation from Concord Academy in Massachusetts on June 5. Caroline got good grades, excelled at several sports, and showed an aptitude for writing, photography, and painting.

Zealously protective of her own privacy, Caroline refused her mother's request that she "come out" as a debutante, as Jackie had twenty-eight years earlier. And Caroline also decided that she would take a year off before starting college and enroll in a Work of Art program at Sotheby's in London.

LEFT Caroline puts on a brave face as she is whisked from her London residence, the home of family friend Sir Hugh Fraser, a Catholic member of Britain's Parliament, after a bomb intended for Fraser exploded under his car moments before he was scheduled to drive Caroline to Sotheby's. A neighbor, walking his dog, was killed in the blast.

The near loss of her daughter terrified Jackie, but Caroline refused to cut short her stay in London.

BELOW A self-portrait of Caroline in exotic garb, part of an exhibition of her photographs in New York in November 1975. Her subjects included Appalachian Mountain residents, Spanish bullfighters, and her own family. The exhibition received generally favorable critical notices.

1976–1983

*"I don't want the children to be just two kids living on Fifth Avenue
and going to nice schools. . . . I want them to know how
the rest of the world lives."*

—JACQUELINE KENNEDY ONASSIS

✢

*"What ended it was the publicity. I couldn't see spending the rest of my life
with cameras hovering around my head."*

—TOM CARNEY on his failed romance with Caroline

✢

*"His mother laid down the law. She told John in no uncertain terms
that acting was beneath him. . . ."*

—A COLLEGE CLASSMATE OF JOHN'S on Jackie's reaction to his acting ambitions

OPPOSITE Caroline and John share an intimacy while watching the action at the RFK Tennis Tournament,
August 1976.

They were coming into their own now, these two children the world had watched grow up. Enrolled at Radcliffe, majoring in fine arts, Caroline took a summer job as a copywriter with a New York newspaper. Rolling Stone magazine sent her to cover the funeral of Elvis Presley in 1977, but she had to abandon the assignment when gawking tourists and buzzing photographers made her presence too disruptive. Disrupted, too—and for the same reasons—was her first real romance, with the writer Tom Carney. "There were times," a friend said, "when Caroline just wanted to scream!"

"Free at last!" John had exclaimed when he went away to boarding school in September 1976, but the freedom was illusory. His enormous fame still trapped him; his friends had to get used to the constant harassment of photographers whenever they went out with him, and Secret Service agents continued to trail him until his sixteenth birthday in November.

Neither was he free of his mother's influence—or of the burdens of the Kennedy legacy. His overriding ambition in prep school and college, his classmates said, was to be an actor, and his drama teachers agreed that both his movie-star good looks and his acting ability brought him great potential. But his mother would have none of it, insisting that for him to become an actor would besmirch the legacy his father had bequeathed him. During one of many arguments with his mother over this issue, John reportedly put his fist through a wall.

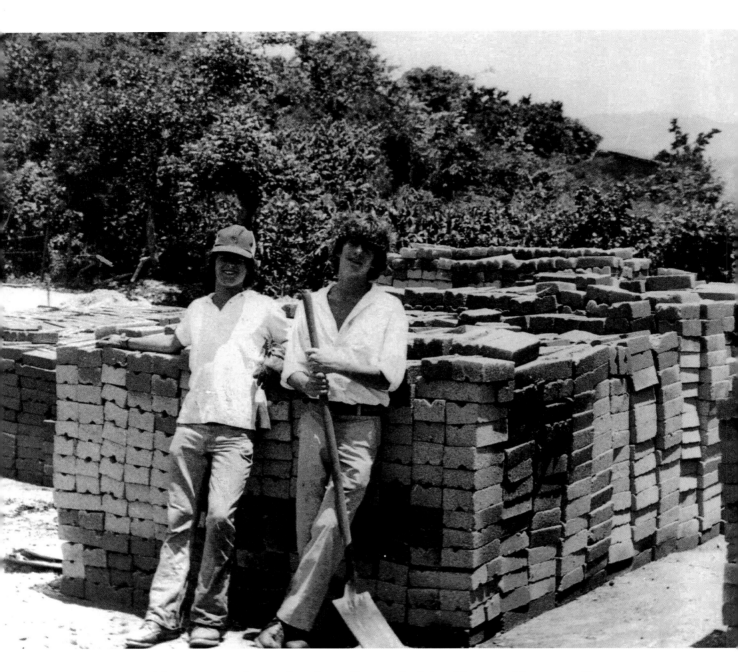

After a catastrophic earthquake in Guatemala, John, fifteen, and his cousin Tim Shriver, sixteen, joined a group of nine young Peace Corps volunteers in order to help the nation rebuild. Here they pose on July 24, 1976, in front of a pile of bricks being used to restore ruined houses in the village of Rabina, where they hauled sand and dug trenches in sweltering tropical weather.

When John came down with mild dysentery, his Secret Service agents wanted to take him to the hospital. "I don't want special treatment!" John insisted, and suffered through the symptoms until he recovered.

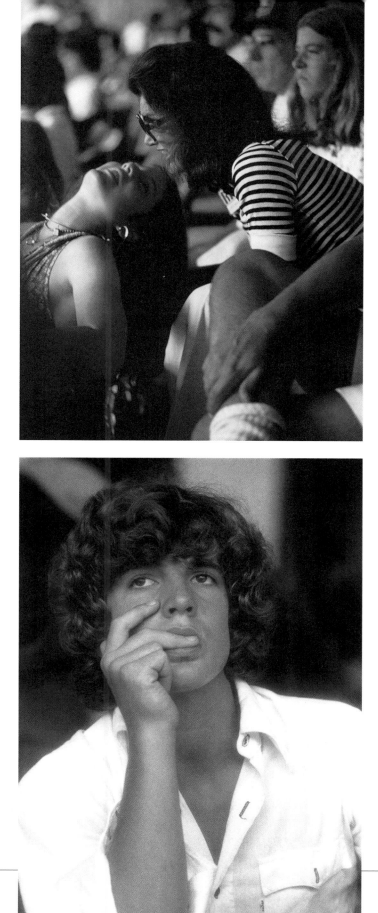

TOP Eighteen-year-old Caroline leans back to say something to her mother at the August 1976 RFK Tennis Tournament. Caroline had enrolled at Radcliffe College, Harvard University's sister school, and was set to begin study that fall.

BOTTOM Also at the RFK Tournament, John seems unusually pensive. He had tried his hand at tennis as a boy, but never became proficient at the sport. It was around this time that commentators began to comment on the young man's extraordinary good looks.

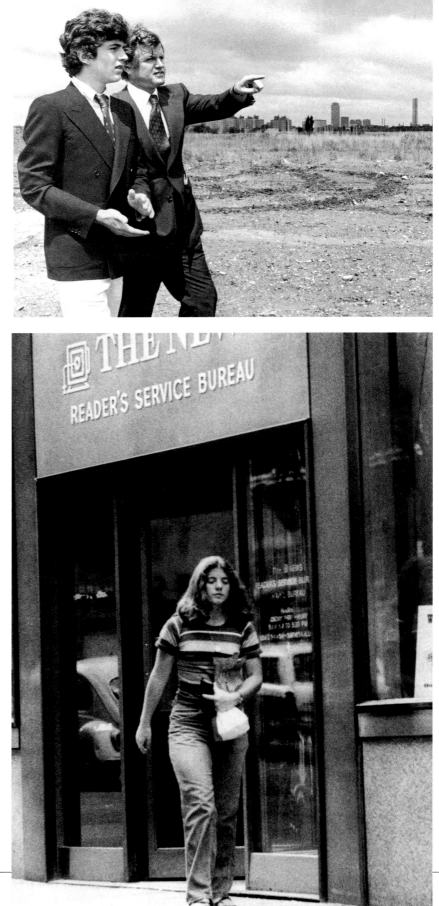

TOP At groundbreaking ceremonies for the John F. Kennedy Library on June 12, 1977, Ted Kennedy points out to John the location of the I. M. Pei–designed building on Dorchester Bay in Boston that would hold the papers and memorabilia of the Kennedy Presidency.

BOTTOM On July 5, Caroline carries a bag lunch as she leaves the New York *Daily News* building in Manhattan. She was working as a copywriter for the summer at the newspaper.

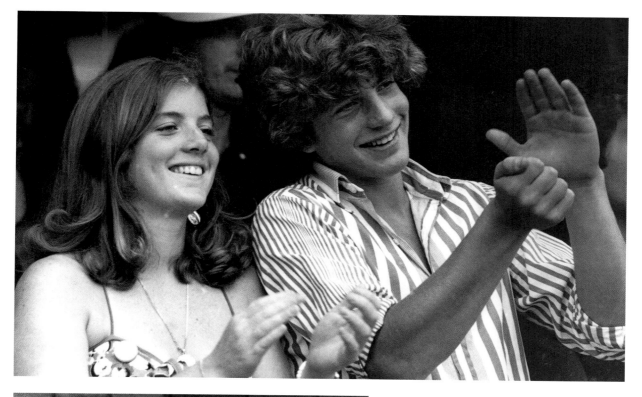

ABOVE At the RFK Tennis Tournament in August 1977, John and Caroline applaud the action. The two were closer than many siblings and formed a tight-knit group with their mother. Although John and Caroline saw their cousins at events like these, Jackie discouraged them from fraternizing too much with them, especially the children of Ethel Kennedy, because she knew that some of them were abusing drugs.

LEFT Caroline interviews mourning fans at the funeral of Elvis Presley in Memphis, Tennessee, August 20, 1977. She was on assignment for *Rolling Stone* magazine but was unable to complete the job because of the distraction her presence created among the public and other members of the press.

ABOVE September 18, 1977: John and Caroline at a party in a New York restaurant following a screening of the Al Pacino film *Bobby Deerfield*.

RIGHT Seventeen-year-old John seems to be enjoying himself at a party at Manhattan's Tavern on the Green following the premiere of John Travolta's film *Saturday Night Fever*, December 12, 1977. The actor James Spader is at left.

Cigarette in hand, John tries to shield himself from the camera as he and his date dance at Studio 54 in Manhattan two days before Christmas, 1977. John was now enrolled at Phillips Academy in Andover, Massachusetts, and had dated Jenny Christian, a tall, blond classmate. The two had starred together in the school's production of *Comings and Goings* earlier in the year, but by now had broken up. They had dated a year before consummating their romance. "I lost my virginity in high school like most other people," John said. "I was kind of a late bloomer, actually."

John sips wine from a Communion cup as Caroline waits her turn during a memorial Mass for Robert Kennedy at Hickory Hill, June 1978.

October 21, 1978: Jackie, John, and Caroline are lost in their memories as Ted Kennedy speaks of his brother at the dedication of the John F. Kennedy School of Government at Harvard University in Cambridge, Massachusetts.

On November 26, Jackie Onassis invited one hundred fifty guests to Manhattan's chic Le Club for a double birthday party for John, eighteen, and Caroline, twenty-one. His voice quavering with emotion, Ted Kennedy toasted his niece and nephew and said, "I shouldn't be doing this tonight. By rights it should have been the father of these two children. Jack loved his children more than anything else."

After the older guests had departed, John remained at the club with friends until four A.M. When he left, photographers accosted him despite warnings from one of John's burlier friends that they were not to take pictures. When flashbulbs popped, "the big guy started punching and kicking," a New York *Daily News* photographer said. When John tried to pull several other friends off a *National Enquirer* cameraman, he slipped and fell to the pavement. The moment was captured in this photo and splashed across the *News's* front page the next day.

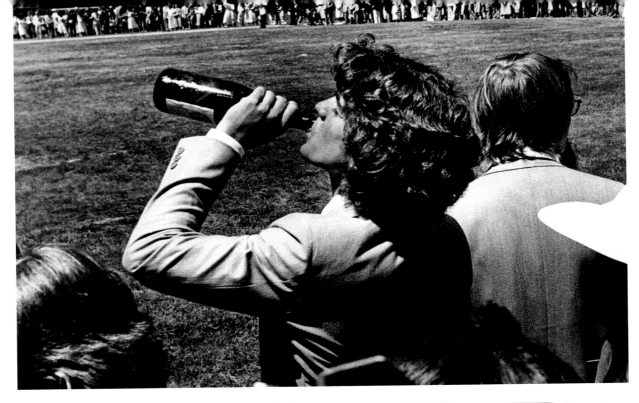

ABOVE John takes a swig from a champagne bottle to celebrate his graduation from Phillips Academy on June 7, 1979. He failed to distinguish himself academically at the school (he had to repeat eleventh grade), and the impression began that John was not highly intelligent. Rather, he might have been dyslexic, although this has never been confirmed. One of his teachers said, "He was intelligent, but not a genius. He was not suited to live the intellectual life. He was always outside, always in motion. He *did things.*"

RIGHT John helps himself to some cake at the RFK Tennis Tournament, August 1979. Unlike his sister, John never had to worry about weight gain. Being in almost constant motion helped him stay fit, as did a strenuous program of weight lifting he began at Phillips. The regimen ultimately gave him a body that earned him the nickname "the Hunk."

September 10, 1979: John waits in line to register as one of 1,305 freshmen at Brown University in Providence, Rhode Island. The presence of photographers upset him, eager as he was to be viewed by his classmates as "a regular guy." He pleaded with them to leave him alone as he registered, and promised to pose for them later. They complied, and so did he.

Caroline walks along Quincy Street outside Harvard Yard in Cambridge, Massachusetts, with her boyfriend Tom Carney on November 7, 1979. Caroline had been dating Carney, a writer, for about a year, following their introduction by her mother. Jackie knew Carney because they both worked at Doubleday, Jackie as a book editor and Carney as a copywriter. A Yale graduate, a Catholic, and ten years Caroline's senior, Carney had Jackie's seal of approval as husband material for her daughter. But the couple broke up in 1980. "What ended it was the publicity," Carney said. "I couldn't see spending the rest of my life with cameras hovering around my head."

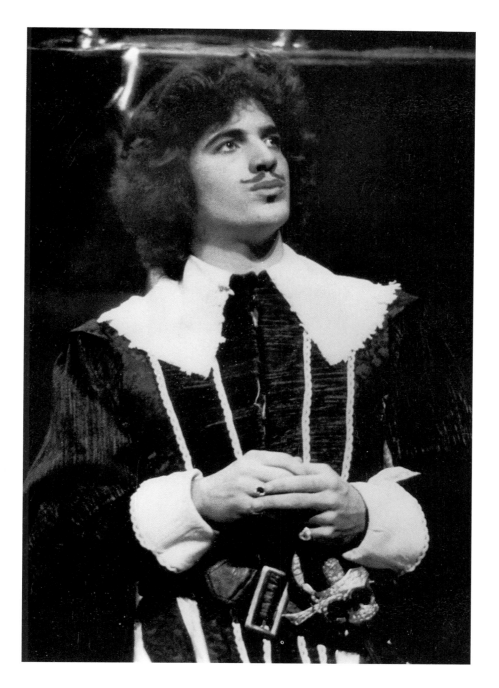

March 13, 1980: John in costume as Bonario, a professional soldier, in Ben Jonson's 1606 play *Volpone*, presented during John's freshman year at Brown University. Don Wilmeth, the head of Brown's drama department, thought highly of John's talent. "He's a very sound actor, very directable. If he had taken theater seriously, he could have been wonderful."

John *was* serious about acting—friends described it as a "passion"—but given his mother's fierce opposition to its being anything more than a college lark, he realized that making the theater his career would be impossible and ultimately gave up the dream.

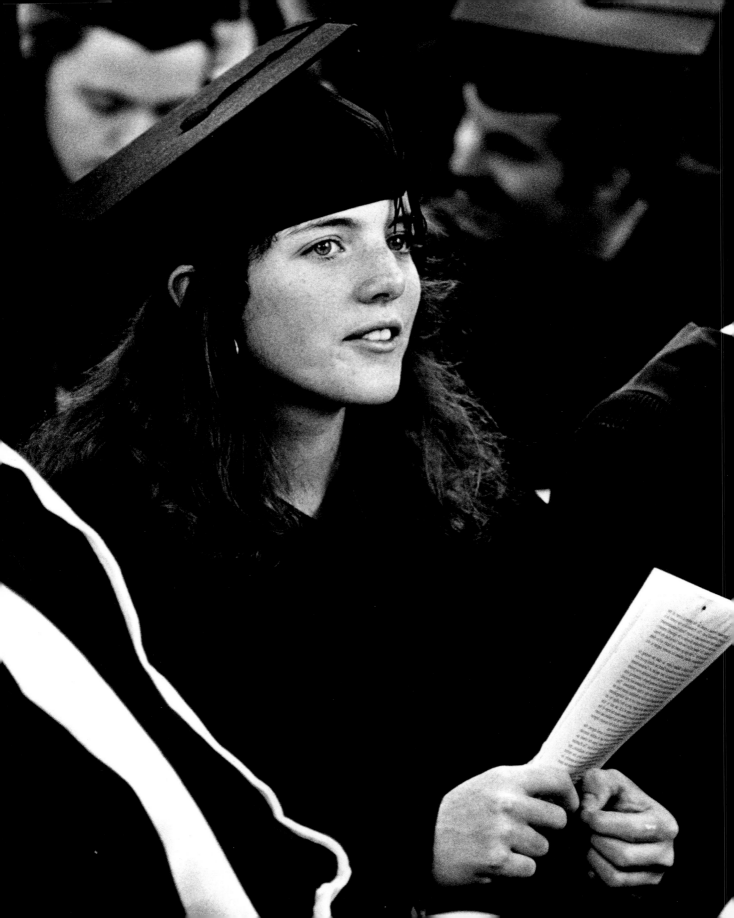

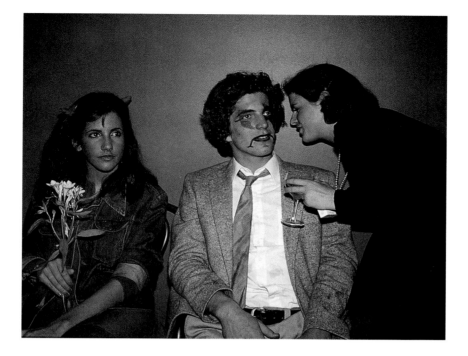

ABOVE John and his friends at a Halloween party, October 31, 1980. John enjoyed dressing up in costumes and seemed to have a bit of an exhibitionist streak. He once went to a Halloween party as Michelangelo's statue of David, wearing only a fig leaf—a costume that showed off his nearly perfect physique quite nicely.

OPPOSITE Caroline at her graduation from Radcliffe, June 5, 1980. She received an A.B. degree in fine arts. During her college years, Caroline worked in her uncle Ted's Washington, D.C., office as an intern. "He wanted her to understand how the Senate operated and what her father's place was in it," said a family friend.

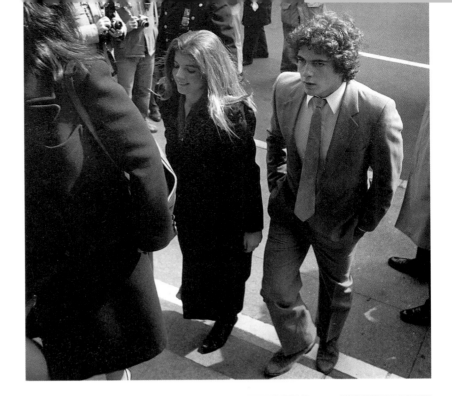

TOP John and Caroline climb the steps of St. Ignatius Loyola Church in Manhattan for the wedding of their cousin Michael Kennedy to Vickie Gifford, March 14, 1981.

BOTTOM A member of the Metropolitan Museum of Art team, Caroline competes in the Manufacturer's Hanover Corporate Challenge Road Race in New York's Central Park on June 24, 1981. Shortly after her graduation from college she had begun to work at the museum as a production assistant for the film and television development division.

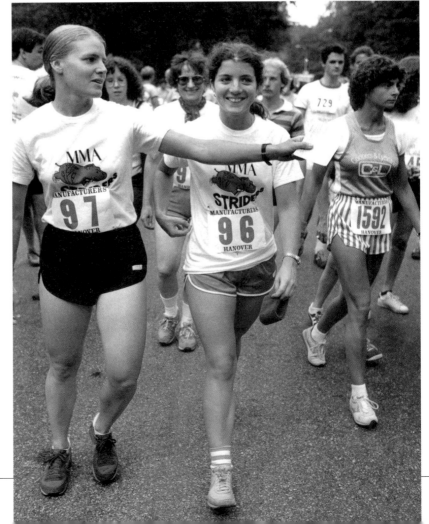

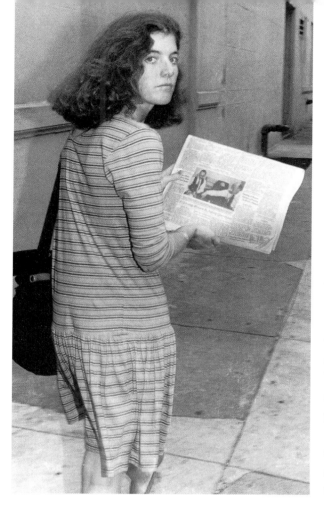

LEFT Caroline's displeasure with a trailing photographer is clear as she walks down Eighty-fifth Street on September 17, 1982. Caroline had hated the constant attention of the public and photographers since she was a little girl and had once begged, "Please tell me when nobody's watching."

BELOW At the Kennedy Space Center in Florida on March 15, 1983, Caroline, twenty-five, poses with her fiancé, multimedia artist, writer, and video producer Edwin Schlossberg, thirty-seven, the son of a wealthy textile manufacturer. The two met at a dinner party late in 1980 and worked together at the Metropolitan Museum. Shortly after meeting, they were living together in Schlossberg's multimillion-dollar Manhattan loft. Jackie, impressed by Schlossberg's social standing and his dual doctoral degrees in science and literature, approved of the match; she proudly introduced Schlossberg to friends at her 1980 Christmas party. After their appearance at another party in Aspen, Andy Warhol wrote in his diaries, "Saw Caroline and the Schlossberg boy. They're madly in love."

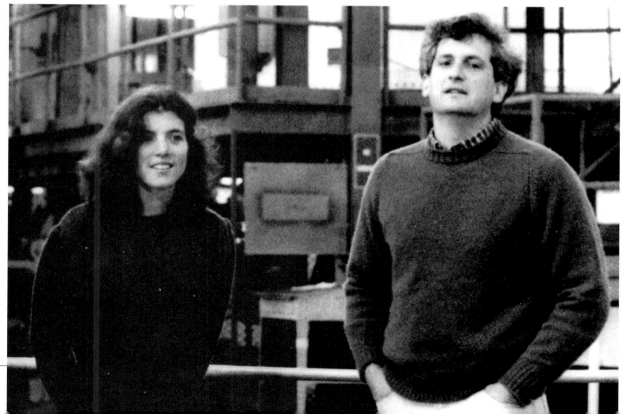

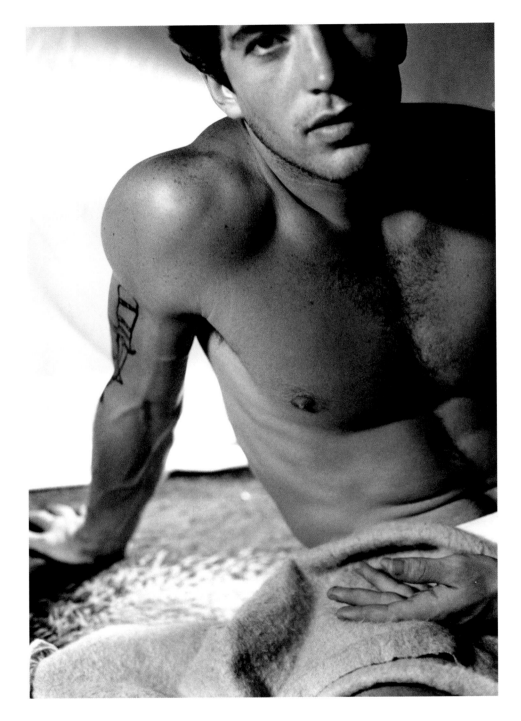

After playing a tough, tattooed inmate in Brown University's production of Miguel Pinero's wrenching prison drama *Short Eyes* in April 1983, John posed for a series of provocative seminude photographs. Shots included John lying languidly on a bed, only a fur throw covering his midsection, close-ups showing his back and chest muscles, and a profile of his torso revealing a firm and protruding nipple. The photographs were not published until after his death.

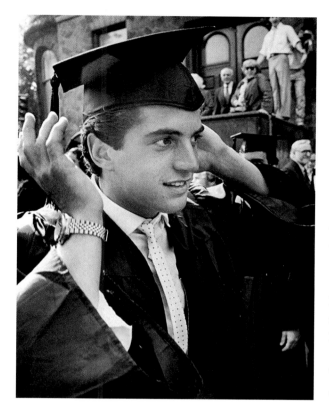

LEFT June 6, 1983: John adjusts his mortarboard in preparation for his graduation from Brown with a bachelor's degree in history. The day proved bittersweet for the Kennedys because it was the fifteenth anniversary of Bobby Kennedy's death. The day before, Senator Edward Kennedy had delivered Brown's commencement address. Deviating from his remarks, his voice cracking as he looked at his nephew in the group of graduates, the Senator said, "I know how much my brother Jack cherished John's future— and how proud he would be if he could be here today."

BELOW Jackie, Caroline, and Ed Schlossberg stroll the beach at Hyannis on the twentieth anniversary of President Kennedy's assassination, November 22, 1983. Earlier in the day Caroline had spoken at a Washington, D.C., memorial service for her father, which was telecast that evening.

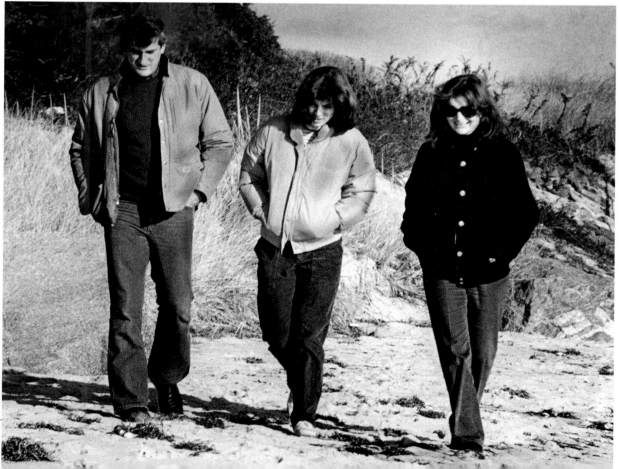

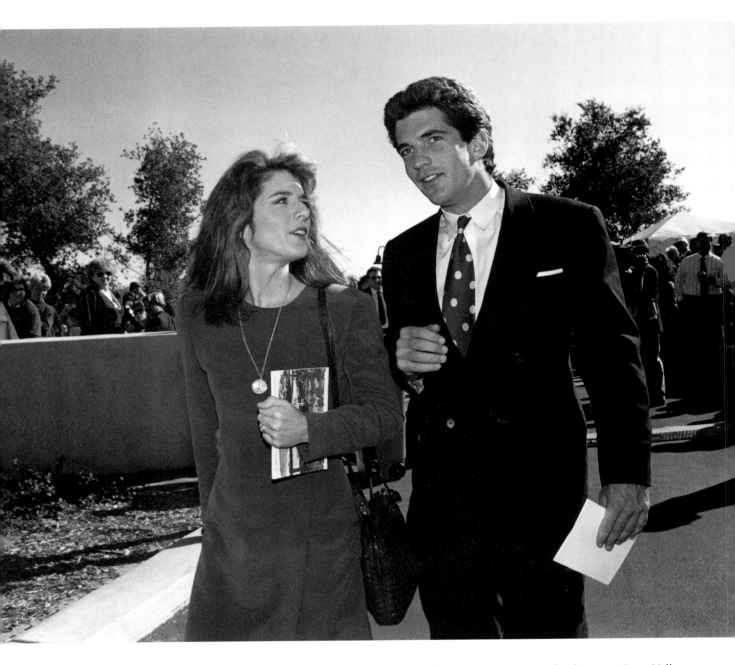

John and Caroline at the dedication ceremonies for the Ronald Reagan Presidential Library in Simi Valley, California, November 4, 1991.

1984–1994

"Gee, John, so you're the sexiest man on the planet? Is that this *planet?"*

—John's friend RICHARD WIESE, teasing him about his designation by *People* magazine as "The Sexiest Man Alive" in 1988

❧

"I failed the bar exam too. It didn't stop me, and it won't stop you."

—New York City Mayor ED KOCH, in a letter to John

❧

"All our lives, it's just been the three of us—Mommy, Caroline, and me. Now there is a fourth."

—JOHN'S toast to Caroline and Ed Schlossberg at their wedding reception

They were adults now, determined to forge their own ways in life, personally and professionally. John made an emotional appearance before the 1988 Democratic National Convention and so impressed the public that People *magazine named him "The Sexiest Man Alive" shortly afterward. He dated glamorous women—the pop queen Madonna, the actress Daryl Hannah—which didn't please his mother, and received a degree in law, which did. He went to work for the Manhattan District Attorney but twice failed his bar exam, which prompted the embarrassing headline* THE HUNK FLUNKS. *But he passed on his third try and won all six cases he prosecuted.*

Caroline, too, earned a law degree, but opted for marriage and motherhood instead of a career. "I'm going to be a grandmother," Jackie had said when she heard the news of Caroline's first pregnancy. "Imagine that." Now that she had matured, married, and given birth, Caroline's relationship with her mother had taken on a more egalitarian nature. A friend of hers recalled, "Jackie was in the sourest mood one day when Caroline and I ran into her. Immediately, Caroline began mimicking her in that high, soft-whisper voice and pretending to be in a tantrum. In a couple of seconds she had her mother laughing and had turned her whole mood around. They are each other's life-support system."

Their mother's life came to an end in 1994, leaving John and Caroline the two remaining members of the First Family of Camelot.

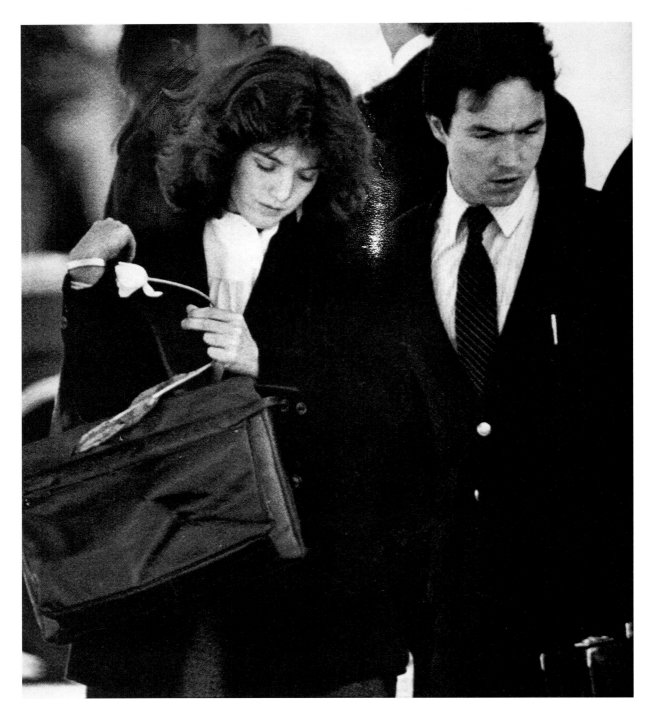

Caroline arrives at Boston's Logan Airport to attend the funeral of her cousin David Kennedy, April 27, 1984. The twenty-nine-year-old son of Robert and Ethel, who watched his father's assassination on television at thirteen, was a heroin addict and died after injecting himself with a combination of cocaine, the tranquilizer Mellaril, and Demerol in a Palm Beach, Florida, hotel room. Caroline took on the heartbreaking task of identifying David's body at the morgue.

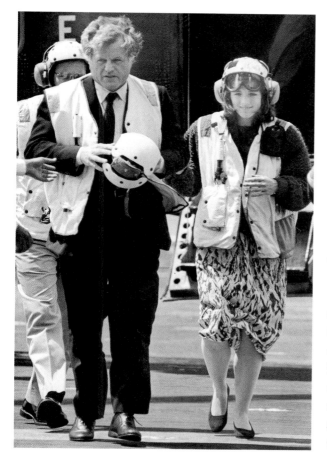

LEFT On June 4, Caroline and her uncle Ted leave a helicopter onboard the USS *John F. Kennedy.* They took a tour of the huge aircraft carrier, which was on an extended visit to Boston.

BELOW John and his girlfriend, Brown classmate Sally Munro, talk to a mutual friend during a night out in July 1984. Irish and a native of Marblehead, Massachusetts, Munro strikingly resembled Caroline Kennedy and was frequently misidentified as John's sister by photographers. The relationship had begun in 1979 and lasted five years, but apparently wasn't exclusive. "When she wasn't around," one of John's fraternity brothers said, "[John] did date a couple of other girls. You've got to remember, his phone was ringing off the hook with calls from girls he knew— and some he didn't know. Women were mailing him their *panties. . . .*"

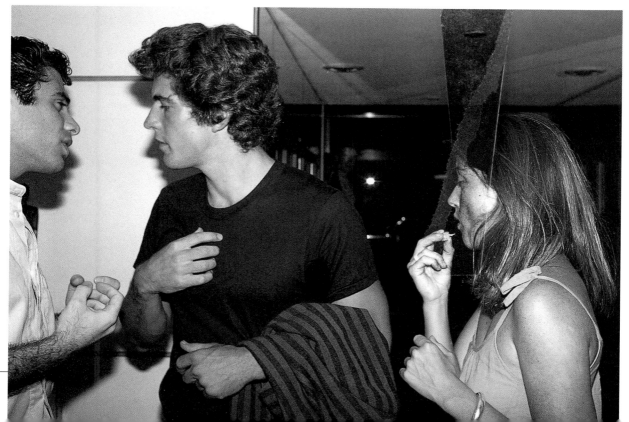

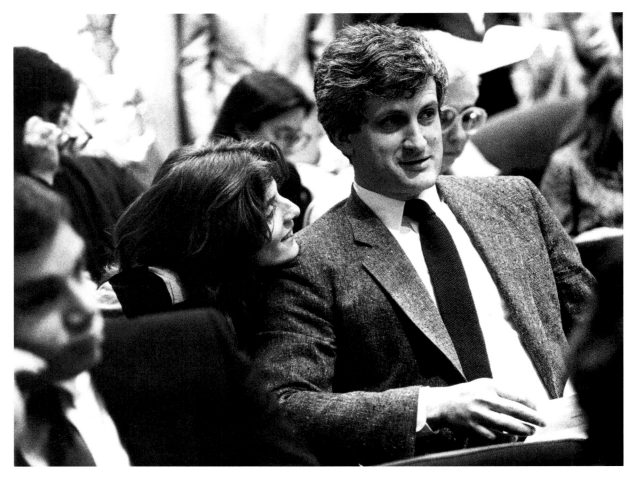

ABOVE Ed Schlossberg and Caroline share an intimate moment at an auction of prints by contemporary artists at Christie's auction house in New York on April 18, 1985. Several of Schlossberg's prints were up for auction, and at one point he put in a successful bid for a work of one of his colleagues.

RIGHT March 29, 1985: Caroline leaves Hofstra University in Hempstead, New York, after attending a conference entitled "John F. Kennedy: The Promise Revisited."

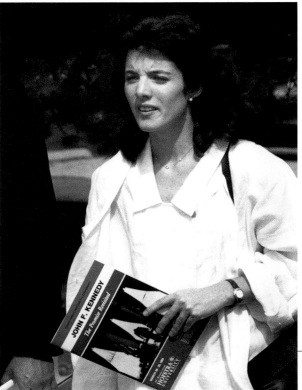

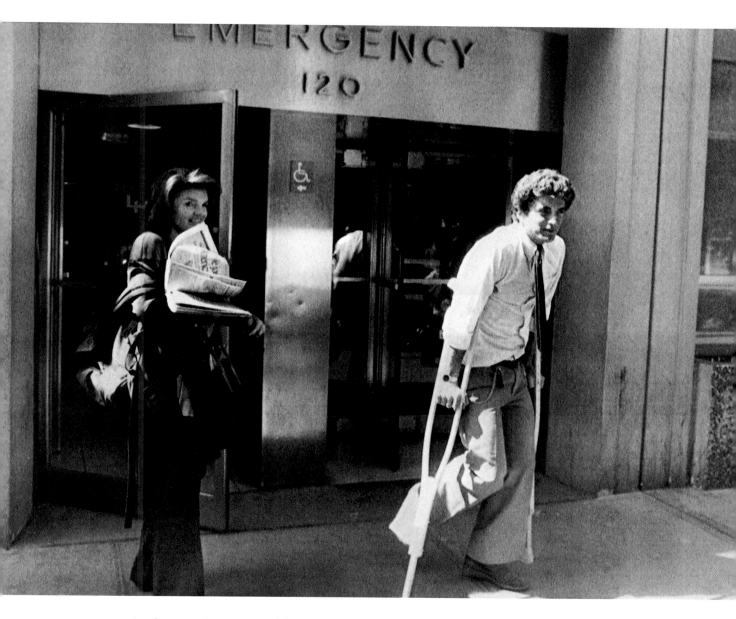

April 1985: Accompanied by his concerned mother, John hobbles out of the Lenox Hill Hospital emergency room in New York City. He fractured his ankle on a piece of workout equipment at his gym.

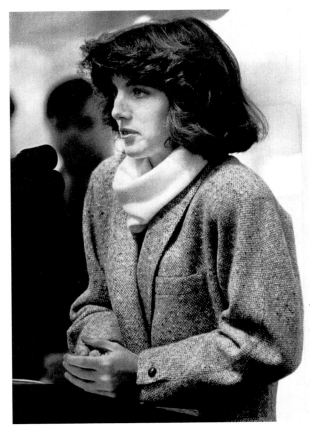

RIGHT Caroline shivers as cold winds blow off the Charles River during the dedication ceremonies for the John F. Kennedy Park in Cambridge, Massachusetts, on November 4. She was the family representative in the planning for the park.

BELOW At the twentieth annual Robert F. Kennedy skating party at the Bedford-Stuyvesant Restoration Center in Brooklyn, New York, on December 14, John joins a group of children participating in the event.

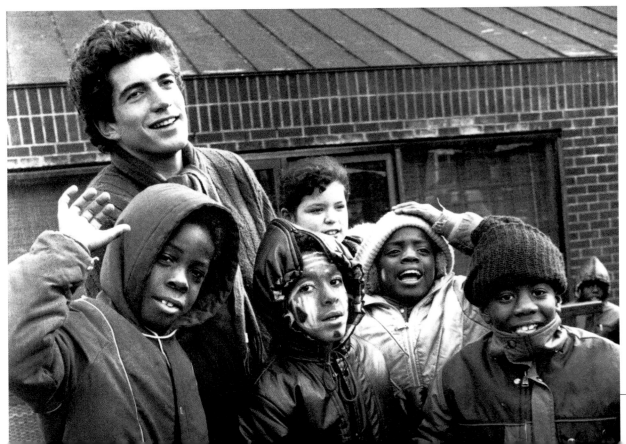

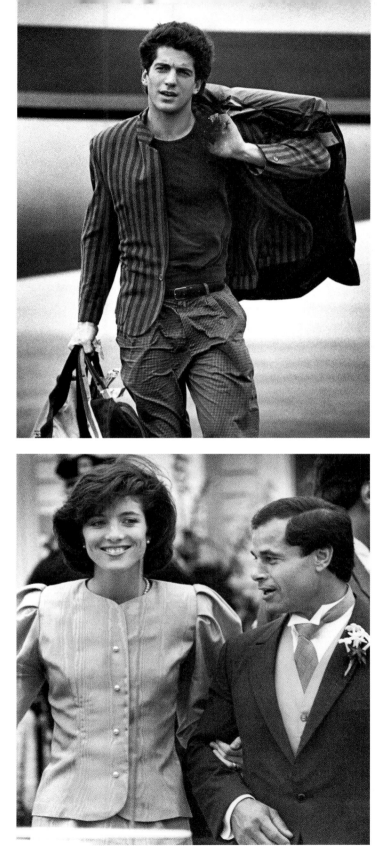

TOP April 25, 1986: John arrives at Barn-stable Airport on Cape Cod, where he will attend the wedding of his cousin Maria Shriver and the bodybuilder and movie star Arnold Schwarzenegger the next day.

BOTTOM Maid of honor Caroline and best man Franco Columbu, a former Mr. Universe and two-time Mr. Olympia in bodybuilding, leave St. Francis Xavier Church after the wedding. Arnold's conservative political leanings caused some consternation among the Kennedys. "Don't look at him as a Republican," Maria Shriver told her uncle Ted. "Look at him as the man I love. And if that doesn't work, look at him as someone who can squash you."

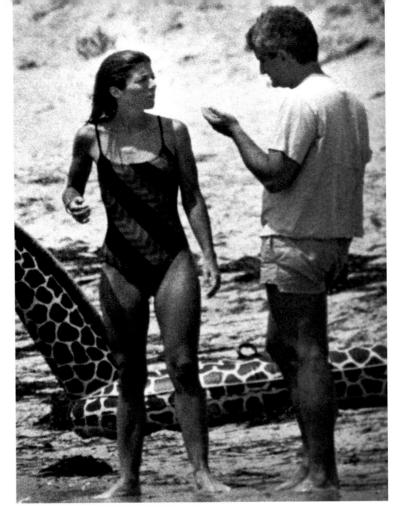

TOP Less than three months after Maria Shriver's wedding, Caroline was set to marry Ed Schlossberg. The day before their wedding, July 18, Caroline and Ed frolicked on the shore of Nantucket Sound on Cape Cod.

BOTTOM John, chosen by Ed to be his best man, dived off a luncheon cruise boat the same day and swam to shore. Between family and friends, John would serve as best man at three weddings that summer.

OPPOSITE Mr. and Mrs. Edwin Schlossberg kiss after their marriage at Our Lady of Victory Church in Centerville, near Hyannis Port, July 19, 1986. Caroline wore a Carolina Herrera gown of white silk organza festooned with embroidered shamrocks.

It was Ed's forty-first birthday, and John Kennedy welcomed him into the family as he toasted the bride and groom: "All our lives, it's just been the three of us—Mommy, Caroline, and me. Now there is a fourth." Ted Kennedy offered toasts as well—to his mother, whose ninety-sixth birthday was days away; to the newlyweds; and finally to the mother of the bride—"that extraordinary woman, Jack's only love. He would have been so proud of you today."

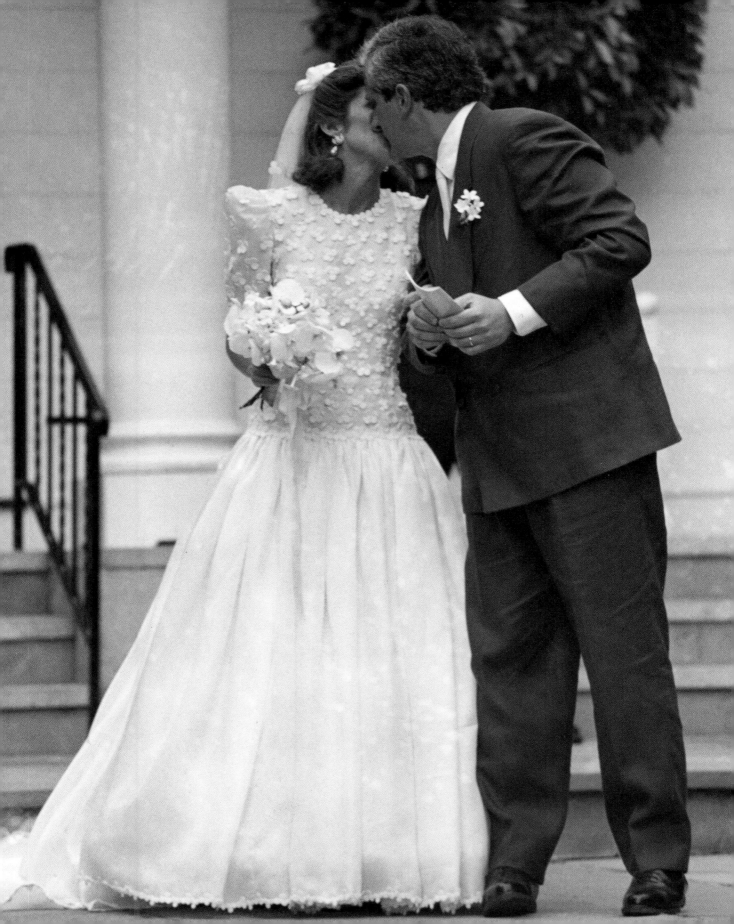

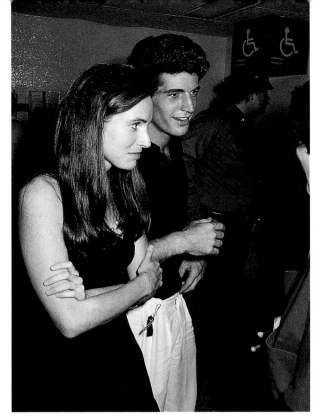

RIGHT John escorts his latest girlfriend, Christina Haag, to a Madonna concert at Madison Square Garden on July 7, 1987. He had known Haag since they were both fifteen—had shared a house with her, future CNN reporter Christiane Amanpour, and two other men while all were students at Brown—and began dating her in 1985 after both starred off-Broadway in Brian Friel's play *Winners*. "We fell in love," Haag said. "We began a romance that lasted until 1991."

BELOW November 26: Jackie and John at the annual Thanksgiving Day foxhunt in Bedminster, New Jersey. They joined eighty other riders belonging to the Essex Fox Hounds Association. John rode to please his mother, but never developed much of a liking for the sport.

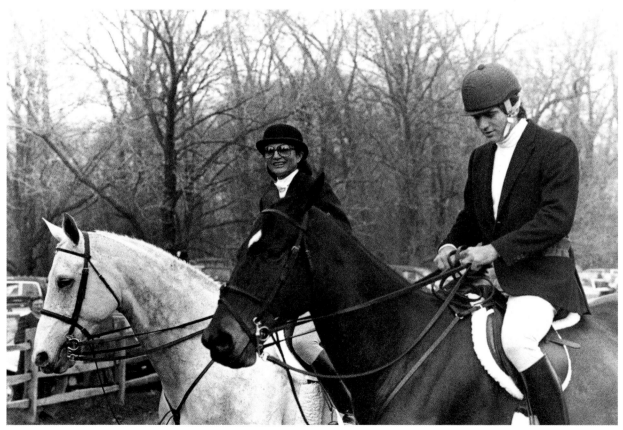

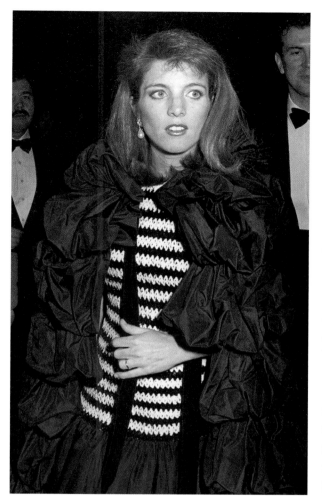

LEFT Dressed to the nines, Caroline attends a gala January 1988 dinner party at the Metropolitan Museum of Art in New York to benefit the museum's Office of Film and Television, for which she and Ed Schlossberg used to work. Jackie Onassis chaired the event, which helped raise money for the distribution of films about art to schools, other museums, libraries, and the home-video market.

BELOW On May 18, Caroline was graduated from Columbia University School of Law, much to her family's pride. Here they beam following a precommencement ceremony at the school. Caroline, thirty, is eight months pregnant with her first child.

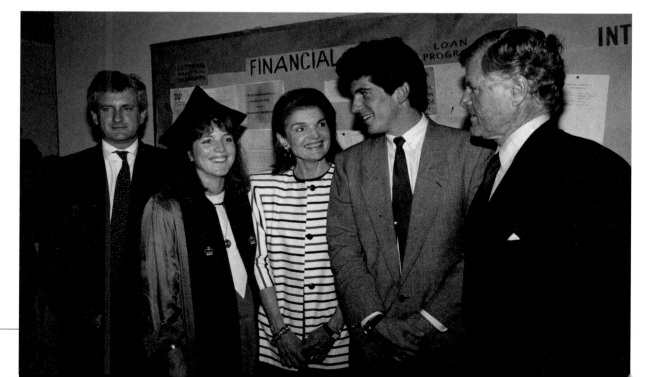

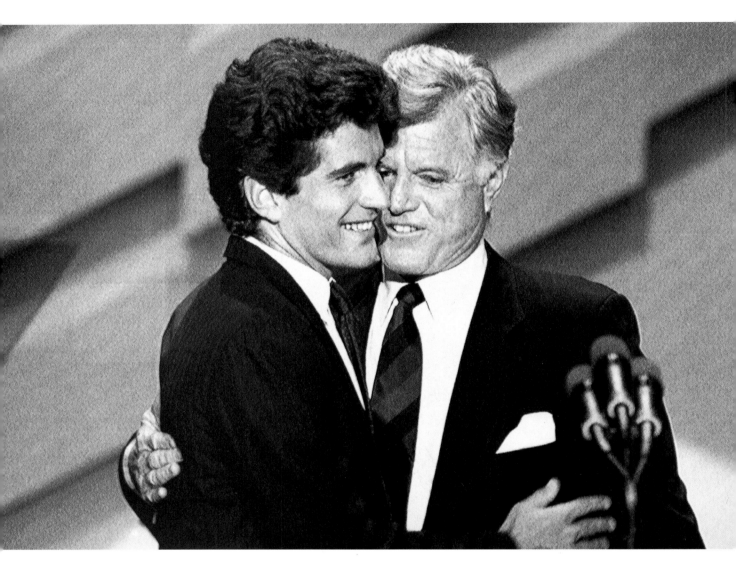

Senator Ted Kennedy embraces his twenty-seven-year-old nephew after John introduced him to the 1988 Democratic National Convention in Atlanta on July 19. John electrified the delegates with his striking good looks and the evocation of his beloved father. "Over a quarter of a century ago," he said, "my father stood before you to accept the nomination of the Presidency of the United States. So many of you came into public service because of him, and in a very real sense it is because of you that he is with us today."

The impact of John's appearance, which was watched by millions on television, led *People* to name him "The Sexiest Man Alive" two months later. The article, which reportedly embarrassed John and disturbed his mother, began, "Okay, ladies, this one is for you. But first some ground rules. GET YOUR EYES OFF THAT MAN'S CHEST! He's a serious fellow. A third-year law student. Active with charities. Scion of the most charismatic family in American politics and heir to its most famous name."

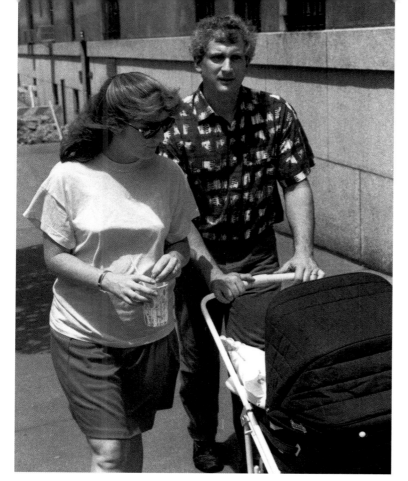

TOP Caroline and Ed walk their three-month-old daughter, Rose Kennedy Schlossberg, in New York, August 1988. The baby was born without complications on June 25, and named after Caroline's paternal grandmother. Jackie was so nervous in the waiting room that John finally told her to "chill out."

BOTTOM John and his cousin William Kennedy Smith appear at Bloomingdale's department store in Manhattan to introduce a line of holiday ornaments crafted by disabled artisans from Brazil, Barbados, Colombia, India, Kenya, and Venezuela. The event was held in conjunction with the Wharton School of Business, whose students also attended the event.

TOP Ted Kennedy and Sydney Lawford join Caroline and Ed at Rose's christening at St. Thomas More Church in New York, December 11, 1988.

BOTTOM May 16, 1989: John and Andrew Cuomo, son of New York Governor Mario Cuomo, on a New Rochelle, New York, radio program to promote Cuomo's nonprofit organization HELP, which builds transitional housing for homeless women and children. In response to a call-in questioner, John said he would not be opposed to homeless housing being built in Hyannis Port. Cuomo went on to marry John's cousin Mary Kerry Kennedy in 1990, and became President Clinton's Secretary of Housing and Urban Development in 1997.

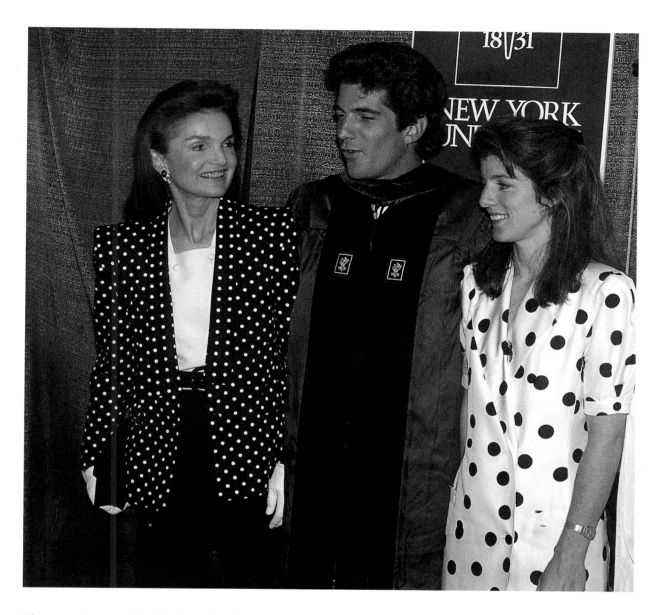

The next day, May 17, John's mother beams as he is graduated from New York University Law School. Now both her children had law degrees, and John seemed to have gotten over his flirtation with an acting career—much to the relief of Mrs. Onassis. "Now I can die a happy woman," Jackie said. She was also relieved when John ended his brief relationship with the pop singer Madonna.

Jackie, a friend said, had "a kind of healthy absorption" with her children's lives. She never stopped showing interest (and sometimes exerting pressure) in everything from their career choices to more mundane matters. As Caroline once good-naturedly complained, "Mom's always on my case about the doctor or the dentist or my clothes."

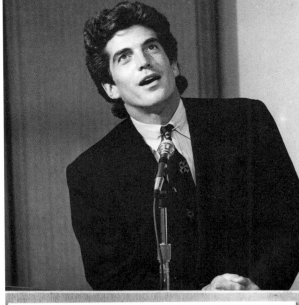

JOHN F. KENNEDY SCHOOL OF GOVERNMENT

RIGHT John marvels at the packed audience as he addresses students at Harvard's John F. Kennedy School of Government on May 25, 1989.

BELOW That same evening, Caroline and Ed walk through a makeshift passageway as they arrive for a fund-raiser for the Kennedy Library Foundation.

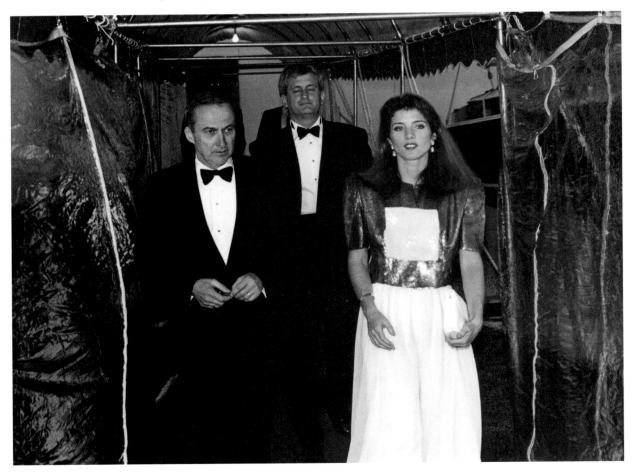

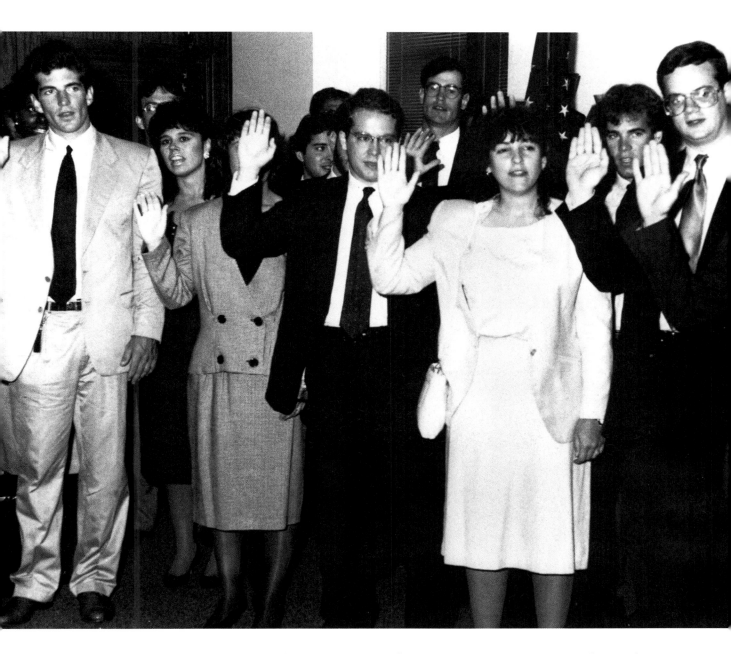

John joins sixty-eight other new assistant district attorneys as they are sworn in on August 21 at the Manhattan District Attorney Robert Morgenthau's office. John would be paid an annual salary of thirty thousand dollars to interview defendants and conduct research. Once he passed his bar exam, he would graduate to prosecuting cases.

Before he began work, however, he had to clear up several traffic violations, ranging from speeding to driving without registration. He also had to pay twenty-three hundred dollars in parking tickets.

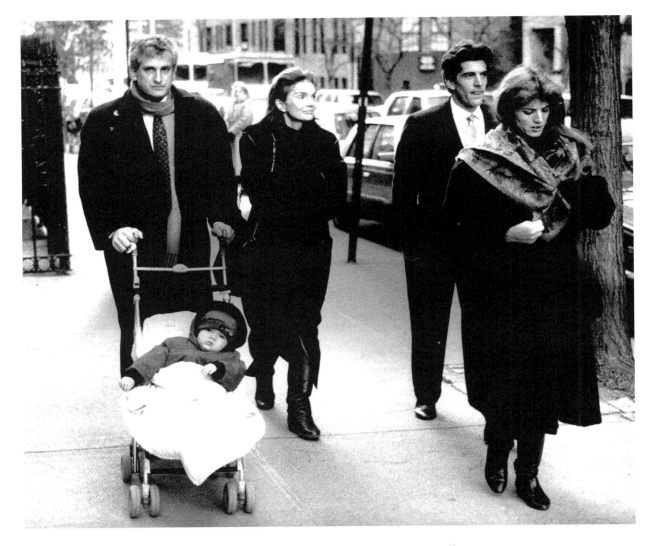

Ed Schlossberg pushes Rose's stroller as he, Caroline, John, and Jackie leave a memorial Mass for President Kennedy at St. Thomas More Roman Catholic Church in Manhattan on November 22, 1989.

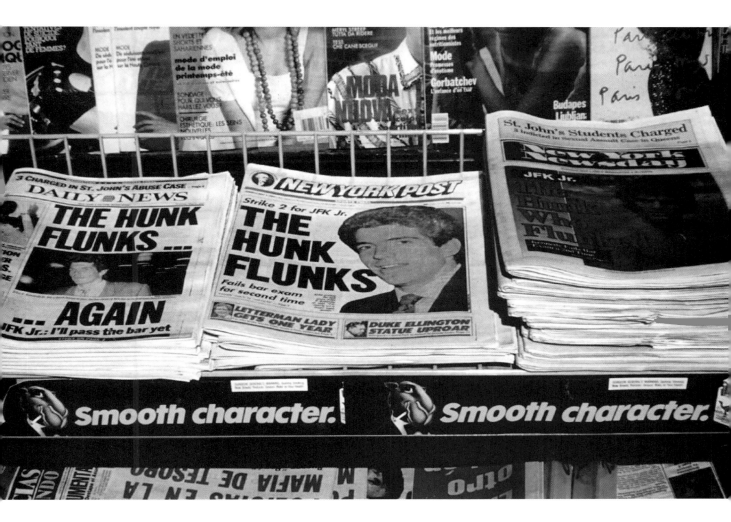

On April 30, 1990, the results of John's second unsuccessful New York State bar exam were released—prompting these embarrassing (and unoriginal) headlines in all three New York tabloids. "God willing," John told a horde of reporters, "I'll go back there in July and I'll pass it then. Or I'll pass it the next time, or I'll pass it when I'm ninety-five. I'm clearly not a major legal genius." His defenders pointed out that he had missed a passing grade by just eleven points, and had attended a law school that does not, like many others, concentrate on teaching students to pass a particular state's exam. His boss in the D.A.'s office later said, "He was very smart, very committed, and a good lawyer."

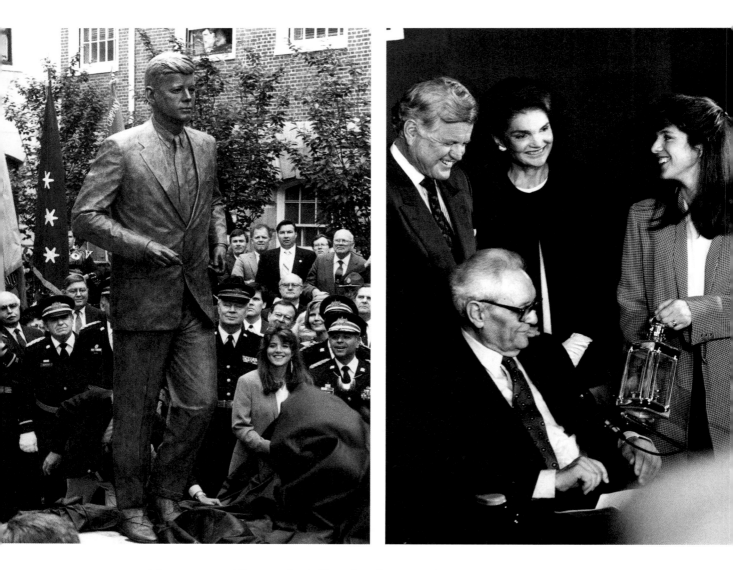

ABOVE LEFT May 29, 1990: Three and a half weeks after giving birth to her second daughter, Tatiana, Caroline attends the unveiling of a statue of her father outside the Boston Statehouse. Caroline had handled all the details of the statue's commission.

ABOVE RIGHT Later that day, her mother and uncle help Caroline present the first annual Profile in Courage Award to Carl Elliott Sr., honored for his participation in the passage of the historic National Defense Education Act of 1958, which made a college education accessible to all, regardless of race or economic status. Caroline had been instrumental in the Kennedy Foundation's establishment of the award, designed to recognize and promote the quality of political courage and leadership that President Kennedy wrote of in his 1956 book *Profiles in Courage*. The award consists of a $25,000 monetary prize and a silver lantern modeled after lanterns found on nineteenth-century sailing vessels. The lantern was designed by Edwin Schlossberg and is crafted by Tiffany & Co.

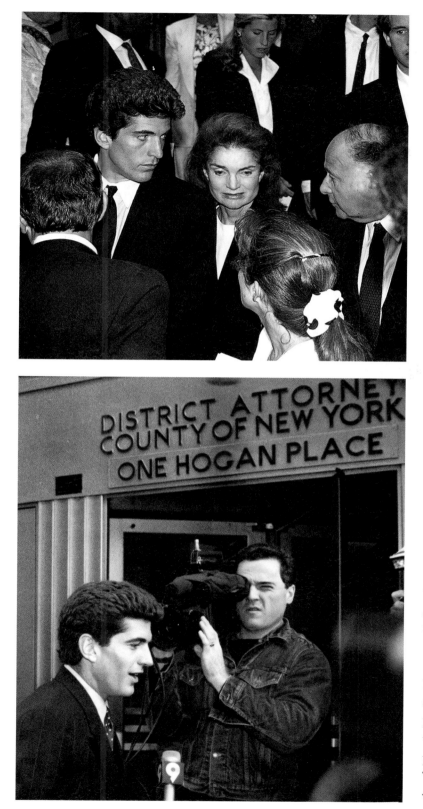

TOP Jackie and John leave the funeral of Stephen Smith on August 20, 1990. Smith, who married JFK's sister Jean Kennedy in 1956, had worked in a Kennedy-owned real-estate investment firm and managed Bobby's 1968 campaign for President. John was particularly close to Jean and Steve Smith because of his friendship with their son Will.

BOTTOM November 17, 1990: A crowd of reporters and photographers greets John as he arrives for work after hearing that he had passed the bar exam on his third try. "I'm very relieved," he said. "It tastes very sweet at the moment."

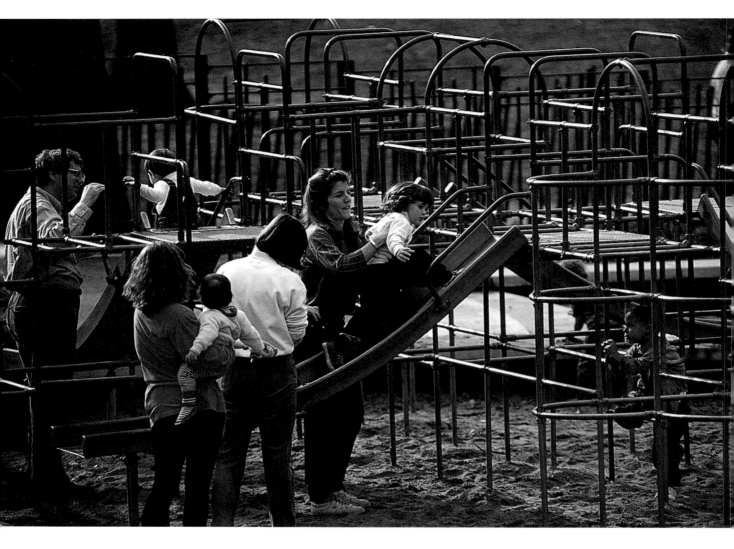

Caroline helps daughter Rose to the top of a slide in a park near their home on March 2, 1991.

ABOVE On May 29, Caroline waits as television cameras are set up for an interview in which she will discuss the importance of the Profile in Courage Award to be presented that evening to former U.S. Congressman Charles Weltner. The date marked the seventy-fourth anniversary of her father's birth.

LEFT John grimaces at the sight of photographers as he and his date, the theater director Toni Kotite, attend a show in Manhattan in 1991.

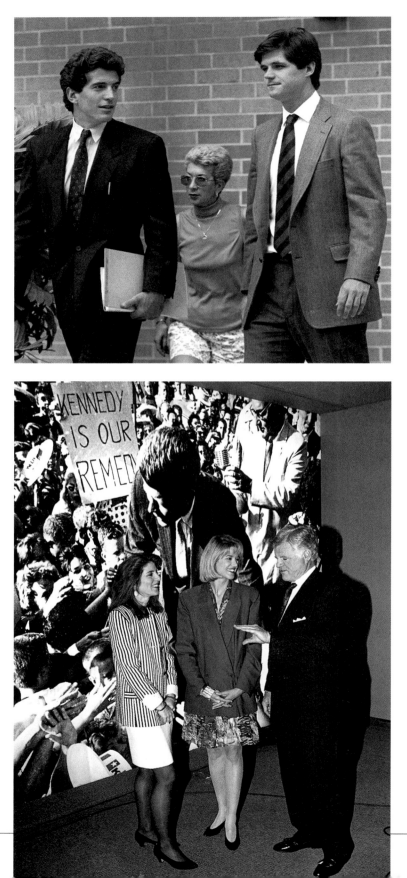

TOP On November 18, John leaves the Palm Beach County Courthouse with his cousin William Kennedy Smith. Smith was on trial on charges that he raped a young woman at the Kennedy vacation home during an Easter holiday that year. "He's helped me in the past and I was glad to come down and be of assistance," John said. "Willie is my cousin. We grew up together. I thought I could at least be with him during this difficult time." Smith won acquittal on the charges.

BOTTOM May 28, 1992: Caroline and Ted chat with the newswoman Paula Zahn at an exhibit at the John F. Kennedy Library in connection with the third annual Profile in Courage Award ceremonies.

LEFT Three months pregnant with her third child, Caroline speaks at the dedication of the Kennedy Children's Garden in New York City on July 15, 1992 . . .

. . . and that evening attends the Democratic National Convention at Madison Square Garden with her husband and aunt Pat Lawford (*far left*). The convention presented a tribute to Robert F. Kennedy and went on to nominate Bill Clinton for President.

ABOVE During a lunchtime break from his law duties on September 24, John plays a game of Frisbee with some friends at a nearby park. An avid enthusiast of physical activity, John biked, skated, swam, sailed, rowed, jogged, waterskied, played Frisbee and football, and worked out nearly every day. Admirers of the male physique duly noted the results.

RIGHT May 22, 1993: Caroline and her daughters, Rose (*left*) and Tatiana, arrive in Hyannis Port for their first visit of the season. A nanny carried the four-month-old baby John Bouvier Kennedy Schlossberg into a rented minivan, which Ed drove to the Kennedy compound. Although Caroline had domestic help, "She was not one to throw everything to the nannies," said Maura Moynihan, daughter of Senator Daniel Patrick Moynihan and a classmate of Caroline's at Radcliffe. "She's a working mother like the rest of us."

John and his new girlfriend, the actress Daryl Hannah, face a gauntlet of photographers as they arrive in Manila, Philippines, on August 7, 1993. (A month earlier, John had quit his job as an assistant district attorney in New York.) Getting past Philippine customs proved a daunting task; at one point officials frisked John.

John had met Hannah first in 1979, when both were eighteen, and then again at John's aunt Lee Radziwill's wedding to the film director Herbert Ross in 1989. They dated a few times after that, despite the fact that Daryl shared a live-in relationship with the singer-songwriter Jackson Browne. She and John saw each other off and on for the next four years, but this trip proved the final straw in her romance with Browne: a month later they bitterly broke up, and John and Daryl became steady companions.

John and Daryl rush past swarming photographers as they arrive at St. Andrew's Church in New Shoreham, Block Island, for the wedding of John's cousin Ted Kennedy Jr. and Kiki Gershman on October 10. The appearance of the Hunk and the Movie Star sent the paparazzi into such a frenzy, onlookers began to shout, "Leave him alone! Leave him alone!"

Rumors swirled that Jackie disapproved of John's involvement with this blond, sexy actress, who reminded many of Marilyn Monroe, but Daryl's mother said, "Daryl told me [Jackie] has been very warm and affectionate." Still, while she might have been fond of Daryl, she did apparently disapprove of John's marrying her—feeling, some said, that the star of a remake of *Attack of the 50-Foot Woman* wouldn't make a suitable wife for the son of John Fitzgerald Kennedy.

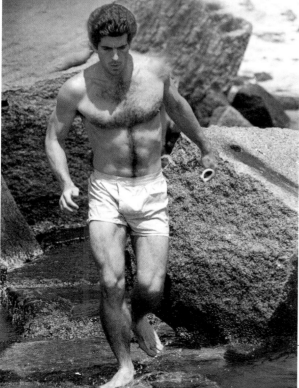

ABOVE John, Caroline, and their mother await the arrival of President Clinton for rededication ceremonies at the John F. Kennedy Library in October 1993. Mrs. Onassis did not know it at this point, but lymphatic cancer had begun to ravage her body, and she would not live more than eight months longer.

LEFT John emerges from the surf of Nantucket Sound during a Kennedy family' gathering at Hyannis Port, 1994.

On May 19, 1994, Jacqueline Bouvier Kennedy Onassis succumbed to cancer at the age of sixty-four. Four days later, John and Caroline followed her casket out of St. Ignatius Loyola Catholic Church in Manhattan on its way to Washington, D.C., and burial next to her husband and infant son Patrick at Arlington National Cemetery.

Shortly before her death, Jackie wrote to her children. She told Caroline that her grandchildren had restored "my faith in the family's future. You and Ed have been so wonderful to share them with me so unselfishly." To John she stressed the legacy he had inherited. "I understand the pressures you'll forever have to endure as a Kennedy. . . . You, especially, have a place in history. No matter what course in life you choose, all I can do is ask that you and Caroline continue to make me, the Kennedy family, and yourself proud."

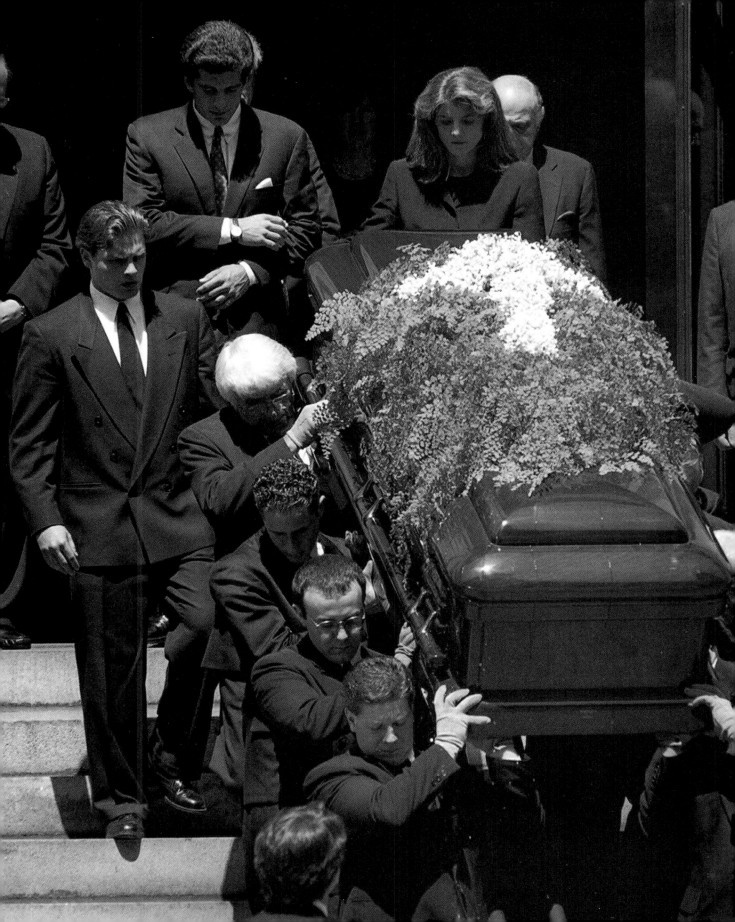

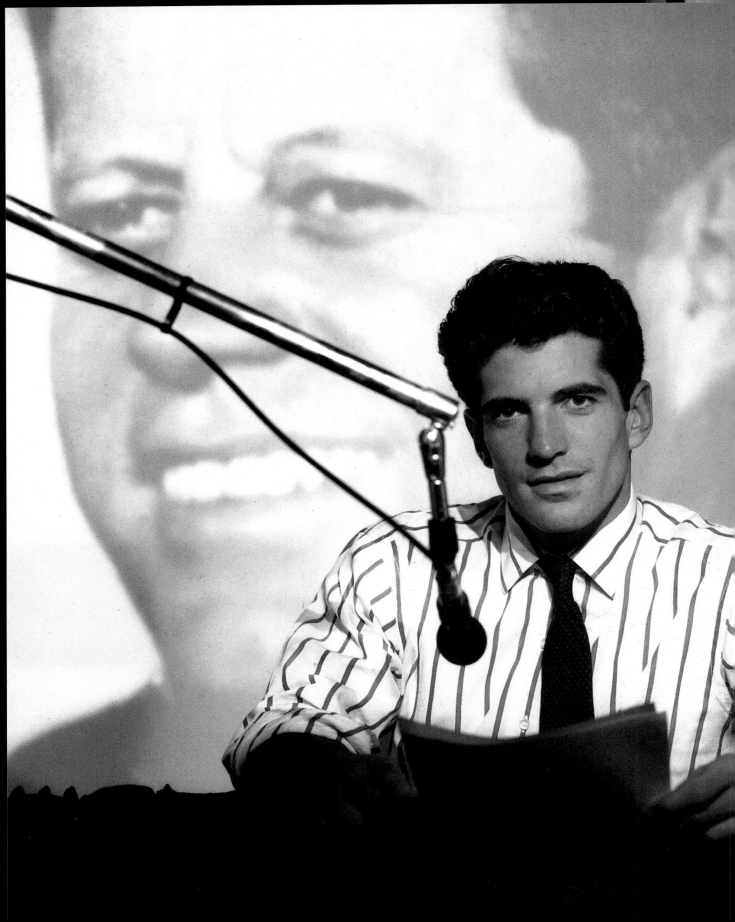

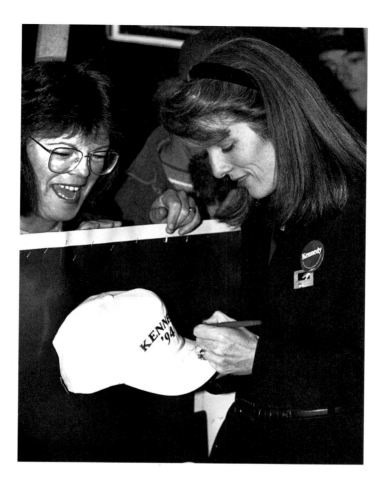

ABOVE November 8, 1994: At St. Bridget's Church in South Boston, Caroline autographs a Kennedy '94 cap for South Weymouth resident Barbara Estano. Caroline and John both campaigned for their uncle Ted, locked in a tough race against Mitt Romney for the United States Senate. Ted went on to win his sixth term.

OPPOSITE Three weeks later, John reads from his father's Pulitzer Prize–winning book *Profiles in Courage* at a symposium in New York City.

After Jackie's death, Daryl Hannah began to pressure John to marry her. He reportedly told her, "I do not respond well to ultimatums," and the relationship soon came to an end.

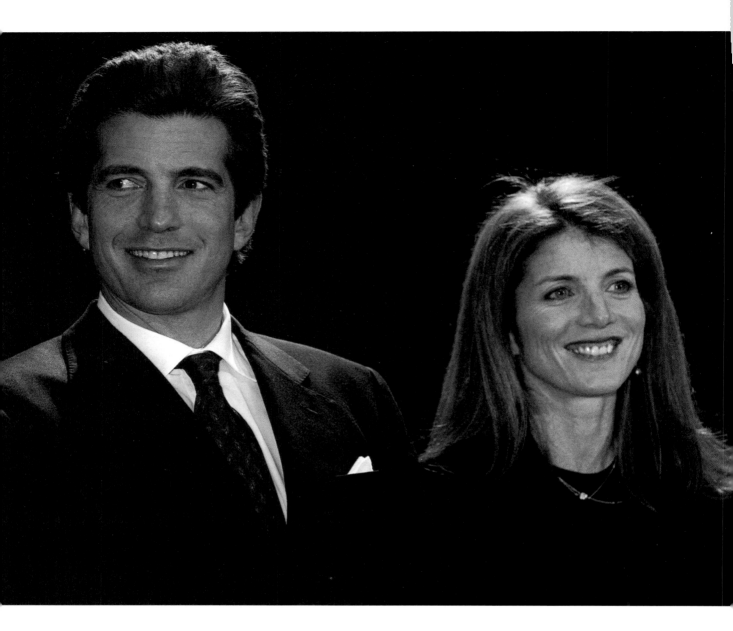

John and Caroline at the Jackie Robinson Foundation Awards dinner on March 8, 1999. Together they do-
nated $125,000 toward an endowment scholarship.

1995—1999

"I feel so lucky to have such a close relationship with her."

—JOHN on Caroline, to Oprah Winfrey

ℒ

"I hope someday to be president . . . of a very successful publishing venture."

—JOHN, slyly, to an advertising group as he promoted his political magazine, *George*

ℒ

"I will be perfectly happy to spend all my days in my apartment writing,
playing with my children, and looking after my husband."

—CAROLINE on whether she might enter politics

"A person never really becomes a grown-up," John said, "until he loses both his parents." One of the sadder elements of the untimely death of Jackie Onassis was that she did not live to see her son create a successful political magazine and settle down into a marriage with a lovely, stylish young woman many compared to Jackie herself.

At the same time, John seemed to crave thrills, risking life and limb to paraglide, pilot airplanes and "powered parachutes," kayak in the wilderness (where he had to rescue a friend from drowning), and deep-sea dive. His mother had adamantly opposed his desire to become a pilot, and despite his sister's frequent pleas for him to honor Jackie's concerns, he got his license to fly four years after her death.

A more serene life contented Caroline, who assumed her mother's positions on many charitable boards, took over as president of the Kennedy Library Foundation, wrote her second book, and reveled in her role as wife and mother. "There is a humility about Caroline," said one of her mother's biographers, Donald Spoto. "She lives her life reflecting her father's best ideals and her mother's way of honoring those ideals."

After the tragic events of July 16, 1999, Caroline found herself the lone surviving member of Camelot's First Family. With the help of her uncle Ted, her grief slowly subsided, and she picked up the mantle as had so many in her family before her.

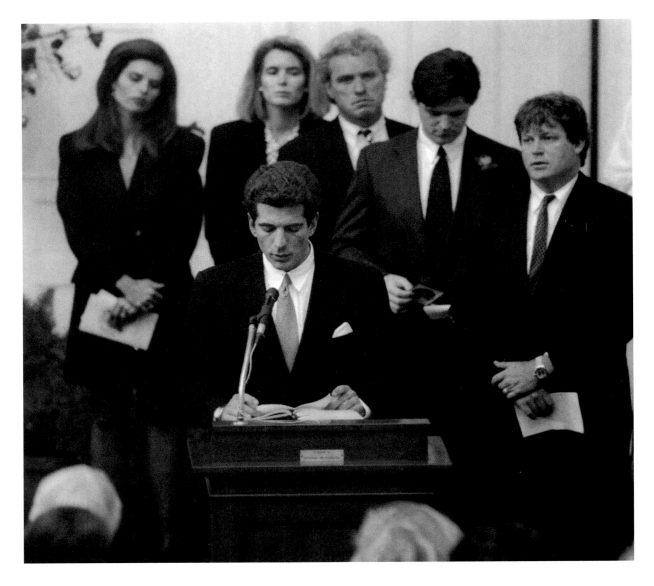

ABOVE A sad duty for John: eulogizing his grandmother Rose Fitzgerald Kennedy at her funeral service on January 24, 1995. The family matriarch died at the age of 104, having outlived her husband, four of her children, and two of her grandchildren. Behind John in this photo are his cousins (*left to right*) Maria Shriver, Sydney Lawford, Joseph Kennedy III, William Smith, and Ted Kennedy Jr.

OPPOSITE A paparazzo catches John and his latest girlfriend (and new roommate), Carolyn Bessette, as they withdraw cash from an ATM in Manhattan on February 26. John had met the statuesque (five-foot-eleven) former model, whose beauty and style many compared to that of Jackie Onassis, while jogging in Central Park in the fall of 1993. By coincidence, the twenty-seven-year-old Bessette, a "personal shopper to the stars" for Calvin Klein, was soon helping John select clothes at the designer's showroom. John came away with a new wardrobe—and Carolyn's phone number.

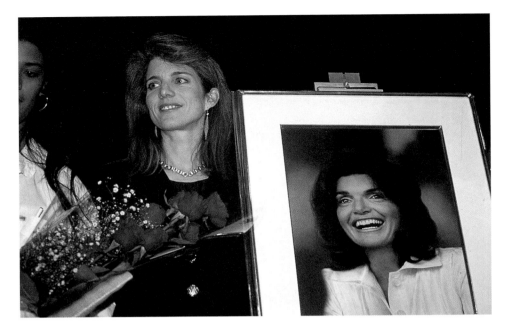

March 22, 1995: Caroline attends the dedication of the Jacqueline Kennedy Onassis High School in Manhattan. The school prepares students for careers in business.

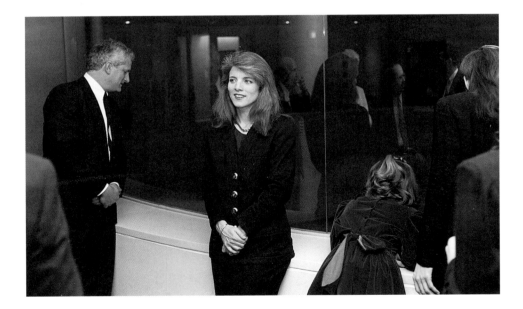

Caroline and Ed stand unaccustomedly alone at a John F. Kennedy Library fund-raiser on March 19. Bandleader Peter Duchin, a friend of the family's, found Caroline "very together and very much in control of herself. She is a very well-balanced and psychologically secure woman." After her mother's death, Caroline assumed many of her positions; she served on the boards of the American Ballet Theater and the Citizens Committee for New York City, and took over as president of the Kennedy Library Foundation.

In June, John traveled to Alabama to interview former Governor George Wallace, who had locked horns with President Kennedy over school integration, for John's soon-to-be-published political magazine, *George*. Former Birmingham City Council President John Katopodis hosted a dinner for the illustrious guest and afterward gave him a bag of Red Man chewing tobacco. "It's redneck Cracker Jack," Katopodis told John. "There's always a surprise inside."

"Really?" John replied, and fished in the bag, where he found a ring. He looked at it and said wonderingly, "It has my family crest on it."

"Really?" marveled Katopodis. "Now, what are the odds of that?" By now John had figured out that his host had had the ring made for him, and he was deeply touched. "No one has ever given me anything like this before," he said.

RIGHT John holds Carolyn tight as they dance at a Manhattan party on July 29. Their relationship, friends said, was the most serious of John's life.

BELOW On September 7, 1995, John launches *George*, of which he was the editor-in-chief, with a great deal of media attention. John intended the magazine to mix politics and entertainment with a dollop of wry humor. The first issue featured a cover shot of model Cindy Crawford dressed as George Washington.

For more than a year, John had traveled the country addressing groups to raise advertising revenue for the magazine. His star quality assured large turnouts, and John turned on the charm in full force. "I hope someday to be president," John would say. Just as the crowd had finished drawing in its collective breath, he'd add, "Of a very successful publishing venture."

After his remarks, John would take questions written on cards, many of which had no queries but rather lipstick kisses and phone numbers. "This isn't right," John would say. "You're supposed to be serious about this." Then, much to the delight of the women in the audience, he would take a closer look at one of the cards and stuff it in his jacket pocket.

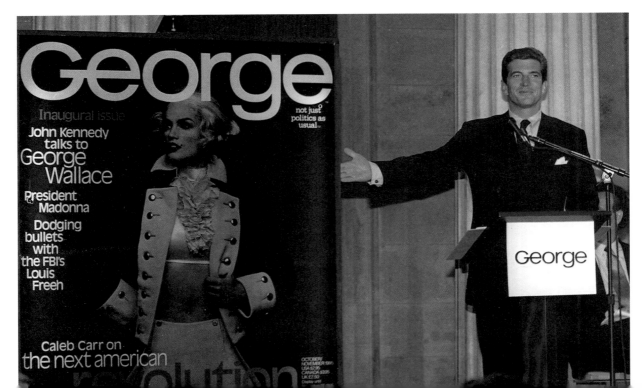

LEFT On September 18, as part of the publicity blitz for *George*, John appeared on an episode of the TV sitcom *Murphy Brown* with Candice Bergen. The brief cameo, in which John presents Murphy with an issue of *George* with her picture on the cover, drew high ratings. On his right hand John wears the ring given him by John Katopodis.

BELOW On February 13, 1996, Caroline and her coauthor, Ellen Alderman, sign copies of their book, *The Right to Privacy*, at a New York City bookstore. "If we do not protect our privacy, it will be taken from us," the coauthors later wrote in a Web site essay. "And if we accept intrusion, we will be conditioned to expect less privacy than we deserve in a free society." Caroline and Ellen, classmates at Columbia Law School, also coauthored *In Our Defense*, a book about the Bill of Rights, in 1991.

ABOVE The next day, John beams approval as Caroline busses the architect I. M. Pei after presenting him with the Jacqueline Kennedy Onassis Medal from the Municipal Arts Society in New York City. Pei designed the striking chrome-and-glass John F. Kennedy Library building. Jackie's efforts on behalf of the Society, which strives to preserve New York City landmarks, helped save Grand Central Station from demolition.

The death of their mother brought John and Caroline closer than ever. Friends said that Caroline had become her brother's "sounding board and confessor," and that the two spoke almost daily on the telephone. They also dined together often, usually at a secluded back table at San Domenico, an Italian eatery near Central Park. The restaurant's manager, Marisa May, recalled, "They would spend hours at the table and laugh a lot. He would always kiss her when he said good-bye."

OPPOSITE In Italy in April to interview the fashion designers Valentino, Versace, and others for *George*, John poses in front of St. Peter's Basilica in the Vatican.

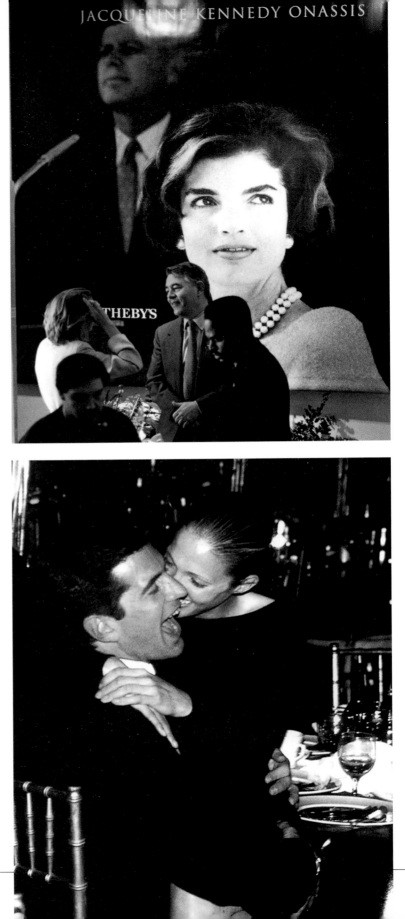

JACQUELINE KENNEDY ONASSIS

TOP Officials of Sotheby's auction house in New York confer prior to the much-anticipated four-day auction of property from Jackie Onassis's estate beginning April 24. Many criticized John and Caroline, believing the auction a crass attempt to make money, but Mrs. Onassis's close friend Nancy Tuckerman pointed out that Jackie, in her will, mentioned an auction as a practical way to deal with the thousands of items of memorabilia she had collected over the years.

John and Caroline donated much of what had historic significance to the Kennedy Library; the remainder was expected to fetch $5 million at auction and help them pay estate taxes on their inheritance. In fact, the "auction of the century" netted $34 million.

BOTTOM John and Carolyn whoop it up during a charity event at a Hilton hotel in New York City on June 12. The couple, obviously besotted with each other, cut strikingly handsome figures together.

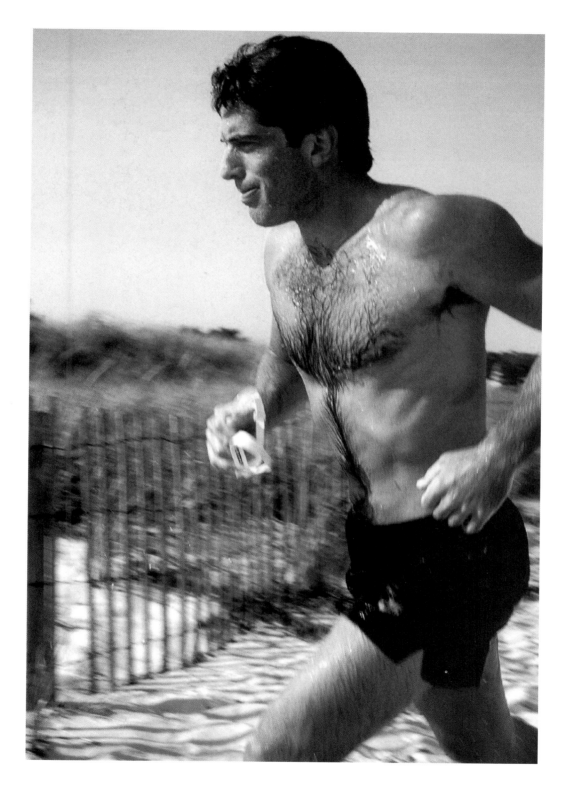

In Hyannis Port for the Kennedy family's annual Labor Day holiday, John runs along the sand dunes after a dip in Nantucket Sound on September 1.

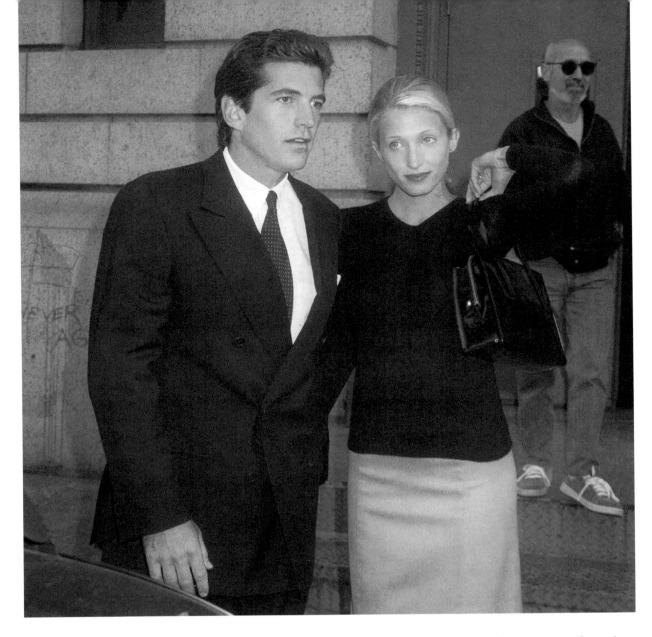

October 6: John and Carolyn meet the press outside their Manhattan apartment after returning from their two-week honeymoon. In a top-secret ceremony that took the world by surprise, the couple were married in a small chapel built by former slaves on Cumberland Island, Georgia. So successfully was the secret kept that the editor of the *National Enquirer* marveled, "John Kennedy could run the CIA." At the candlelit ceremony, Caroline served as matron of honor and John's cousin Anthony Radziwill was best man. Caroline's daughters, Rose and Tatiana, acted as flower girls, and her son, Jack, just three, was the ring bearer.

Carolyn wore a sleek dress of pearl-colored silk crepe with a tulle veil and tulle gloves, designed for her by her friend Narciso Rodriguez for the House of Cerutti in Paris, at a reported cost of forty thousand dollars.

After a reception at the Greyfield Inn on Cumberland Island at which they danced to Prince's "Forever in My Life," the newlyweds left for their honeymoon—three days in Turkey followed by a ten-day cruise of the Aegean Sea aboard the schooner *Althea*.

December 15, 1996: Beleaguered by a particularly bothersome paparazzo, the same woman who had filmed an embarrassing video of John and Carolyn fighting in Central Park prior to their marriage, John reaches the end of his tether and jumps on the hood of her car, shouting, "I know who you are and I'm going to get you! Leave us the *hell* alone!" He then flagged down a policeman to lodge a complaint against his harasser.

John shows off his wedding ring to Rosie O'Donnell during an appearance on her talk show, February 20, 1997.

TOP No, Caroline isn't taking a fashion risk at the John F. Kennedy Library on May 29. She and Ted are standing in front of a display case holding her mother's wedding gown prior to presenting the year's Profile in Courage Award.

BOTTOM President Clinton waves to well-wishers as he and Caroline board Ted Kennedy's sailboat the *Maya* for an afternoon of sailing off Martha's Vineyard on August 20. Clinton felt a close affinity to the family of John F. Kennedy, the man who inspired him to enter politics.

John kept up his strenuous regimen of physical activity even as he entered his late thirties. These photographs, taken in 1997, show him kayaking off Hyannis Port . . .

. . . sitting at the controls of his Buckeye powered parachute while in Argos, Indiana, to visit the Buckeye headquarters . . .

. . . and walking to work with his arm in a cast after what was described as a "kitchen accident" severed a nerve in his right hand.

RIGHT John embraces his cousin Douglas Kennedy as he arrives at Our Lady of Victory Church in Centerville, Massachusetts, for the funeral of Douglas's brother Michael on January 3, 1998. Michael, the sixth child of Bobby and Ethel, died in a skiing mishap in Aspen, Colorado, on December 31. He left a widow and three children.

BELOW President Clinton points out President Kennedy's official portrait to John and Carolyn as they visit the White House on March 5.

OPPOSITE Mr. and Mrs. John F. Kennedy Jr. attend a reception at the John F. Kennedy Library on May 28, 1998.

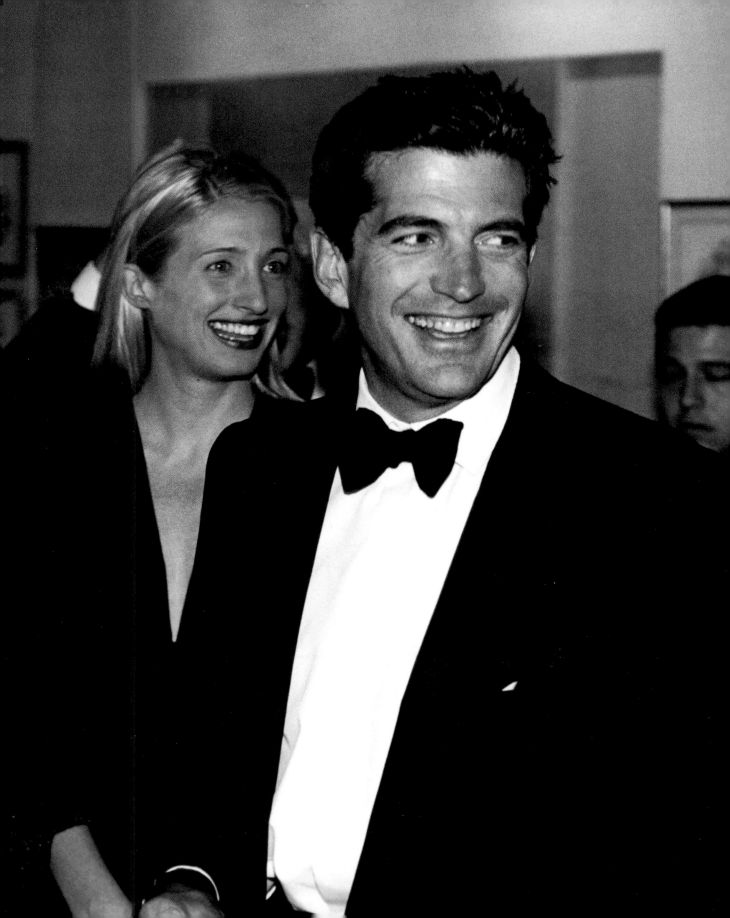

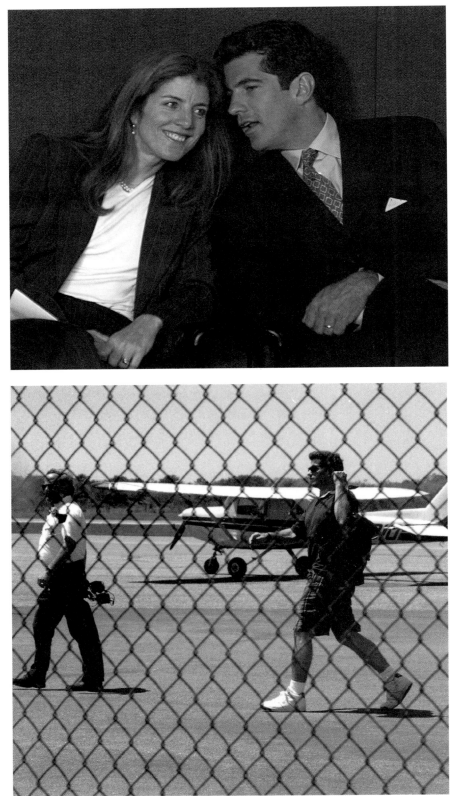

TOP The next day, John and Caroline chat prior to the presentation of the Profile in Courage Award to Montana's Garfield County Attorney Nickolas C. Murnion. Murnion was influential in ending the standoff between FBI agents and the outlaw group Freemen in Justus Township, Montana, early in 1996.

BOTTOM John leaves the airport after flying his Piper Cub airplane on a flight around Cape Cod, May 30, 1998. John had taken flying lessons, against his mother's wishes, while a student at Brown, and again in 1996, this time against the wishes of his bride-to-be, whose concerns for his safety he laughed off with the comment, "You're just being paranoid and superstitious. Don't worry—I won't take any chances."

John had earned his pilot's license in April 1998, and later in the year he purchased a Piper Saratoga.

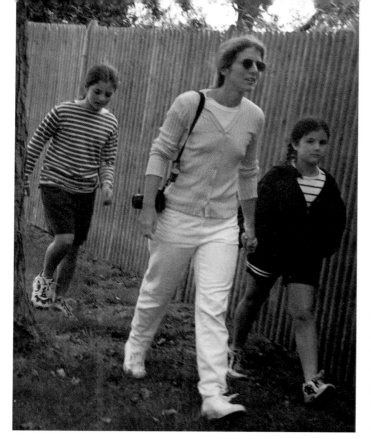

LEFT Caroline, forty, takes a walk with her daughters, Rose, ten, and Tatiana, eight, near the Kennedy compound in Hyannis Port during the Fourth of July weekend.

BELOW Stunningly attired, John, Carolyn, and Caroline attend the gala reopening of the magnificently restored Grand Central Station in the fall of 1998. The project was a favorite of Jackie Onassis, who is credited with saving the station from demolition through her efforts as part of New York's Municipal Arts Society.

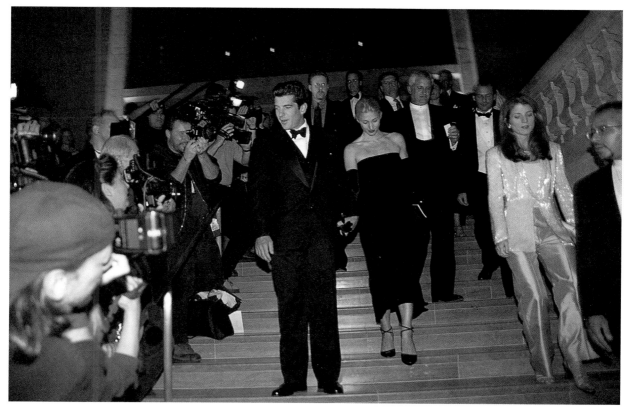

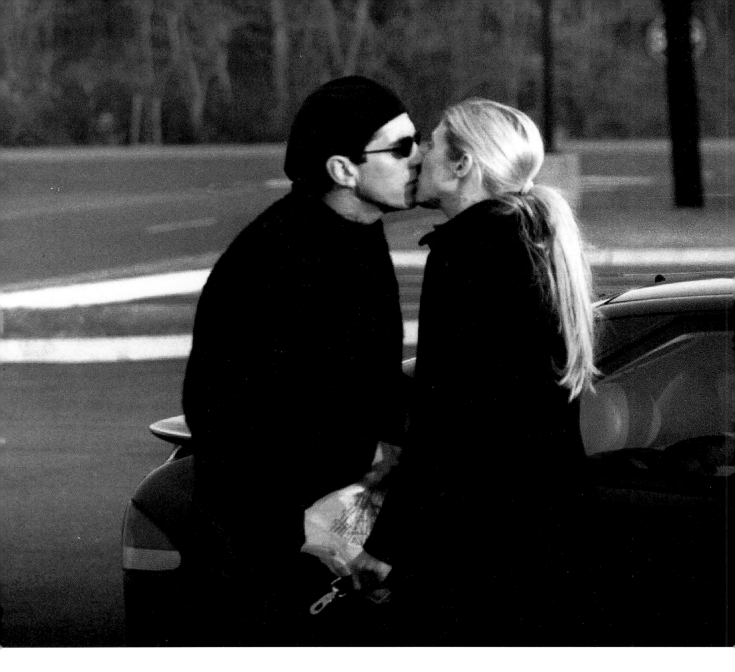

Carolyn gives John a thirty-eighth-birthday kiss near their Tribeca loft on November 25, 1998.

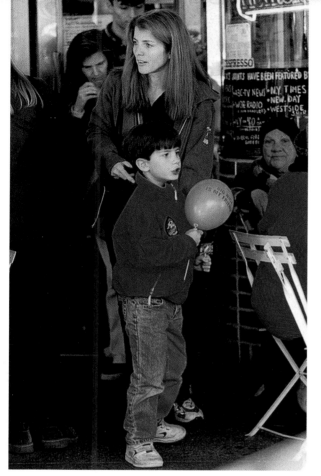

LEFT Jack Schlossberg, six, holds a "Big Nick Is My Friend" balloon as he and his mother leave Big Nick's Burger Joint on Manhattan's Upper West Side on April 30, 1999.

BELOW John and Carolyn nuzzle during the annual White House Correspondents' Dinner in Washington, D.C., on May 1. The couple frequently displayed their affection for each other publicly.

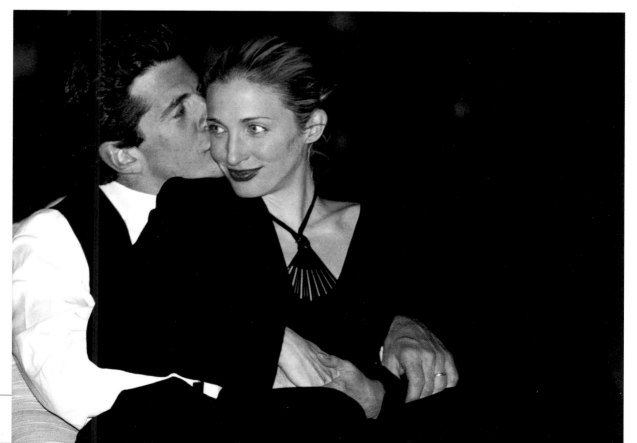

RIGHT May 24: Caroline presents First Lady Hillary Rodham Clinton with the Arts Advocacy Award during the fourth annual National Arts Awards at Lincoln Center in New York.

BELOW His leg in a cast after a paragliding accident, John greets workers at the *George* magazine "Politicians versus Pundits" auto race at the U.S. Arena in Landover, Maryland, on June 15.

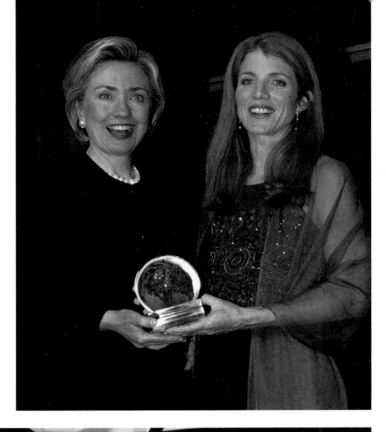

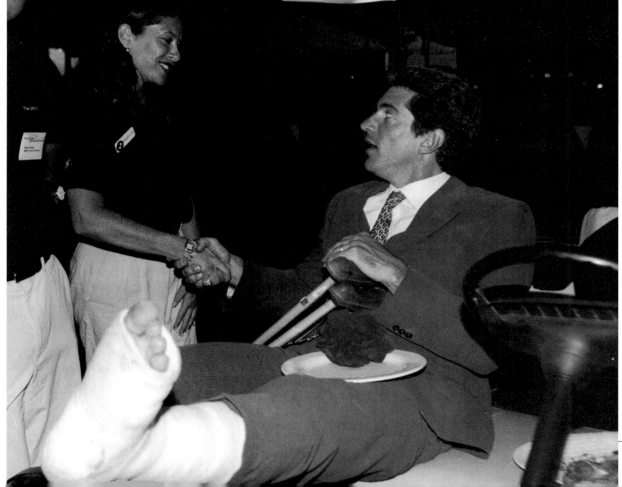

On the evening of Friday, July 16, John, Carolyn, and her sister Lauren took off aboard his Piper Saratoga for his cousin Rory Kennedy's Hyannis Port wedding the next day. The flight was expected to land at eight-thirty. When it hadn't arrived by eleven, Ted Kennedy telephoned John's loft and learned from a friend staying there that John had indeed taken off in his plane for the wedding.

The news that John's plane was missing rocketed out to a shocked world. Rory's wedding was postponed and millions hoped against rational hope that somehow John, his wife, and his sister-in-law would turn up safe and sound.

After three days, the plane—and the bodies of John, Carolyn, and Lauren—were located in the waters off Martha's Vineyard. They had died immediately when the plane hit the water the evening of July 16. An outpouring of grief ensued, especially in New York, where thousands of people left notes, flowers, photos—and this metal sculpture of John saluting his father's casket—outside John and Carolyn's apartment.

ABOVE Attempting to take their minds off their grief, Caroline and Ed take an early-morning bike ride outside their Bridgehampton, Long Island, home on July 20. The day before marked the couple's thirteenth wedding anniversary. Needless to say, Caroline was devastated by the loss of her brother. "He and Caroline were best friends," said John's friend Richard Wiese. "There was genuine love between them."

OPPOSITE Clearly distressed, Caroline arrives at a reception at the Sacred Heart Convent School following a memorial Mass on July 23. The ashes of John, Carolyn, and Lauren had been scattered at sea two days earlier. Ted Kennedy, in emotional remarks, eulogized all three at the Mass, and said of John, "He had amazing grace. He accepted who he was, but he cared more about what he could and should become. He was the Kennedy who loved us all, but especially his sister, Caroline. He celebrated her brilliance and took strength and joy from their lifelong mutual admiration society. And for a thousand days he was a husband who adored the wife who became his perfect soul mate."

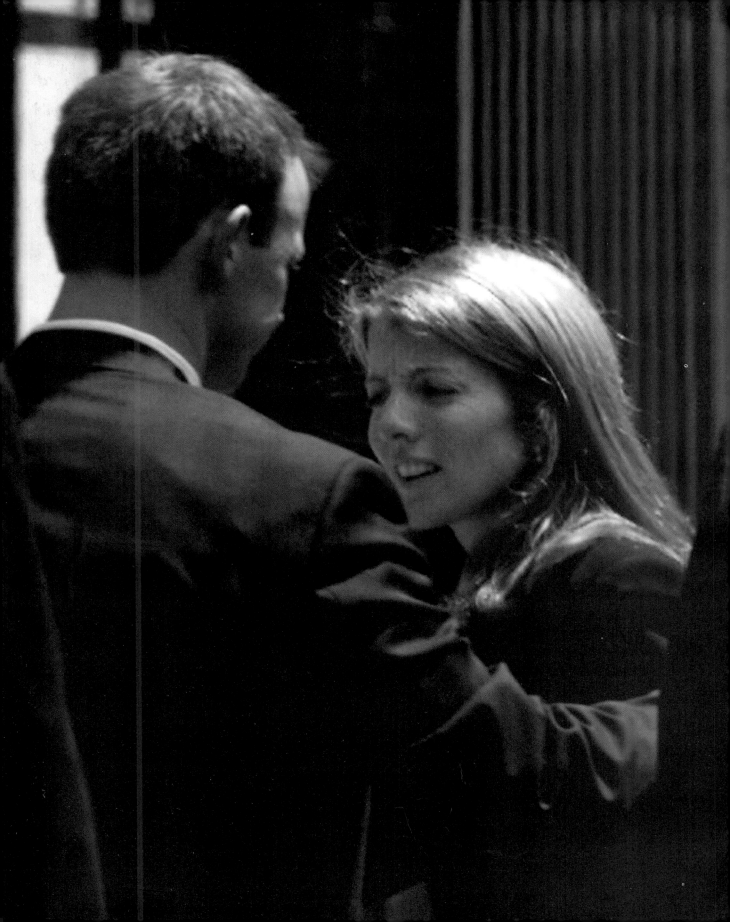

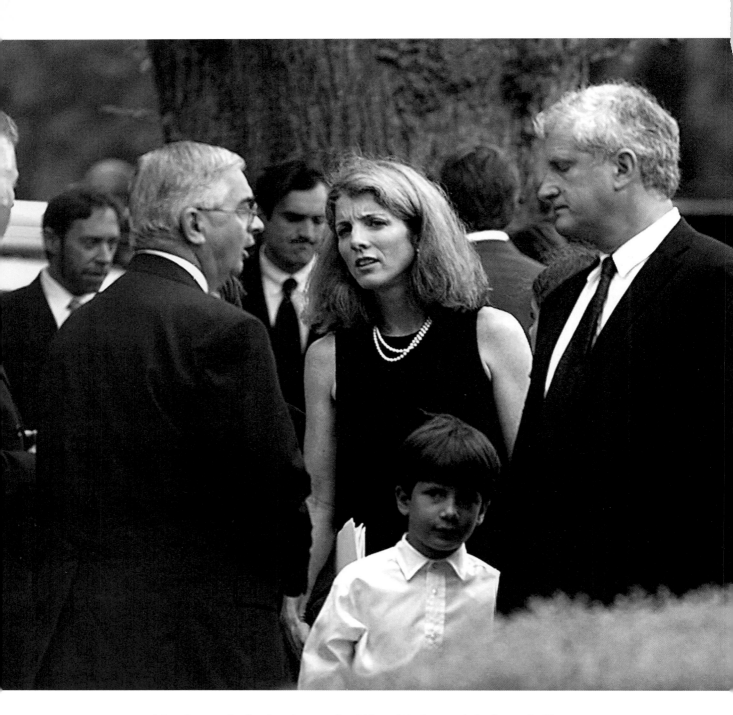

More heartache for Caroline as she, Ed, and Jack attend the funeral of her cousin Anthony Radziwill, who died August 10 at the age of forty after a ten-year battle with cancer. Radziwill, an award-winning documentary filmmaker, had been one of John's best friends.

A far more pleasant duty for Caroline on December 7, as she returns to her seat after delivering remarks at the tenth annual Robin Hood Foundation breakfast in New York. The foundation, on whose board John served, presents its Hero Awards to individuals who have demonstrated leadership in the fight against poverty.

Social worker Rosa Pardo, an award recipient, sat at Caroline's table and was surprised when she said, just before delivering her remarks, "I hope I don't sound like an idiot."

"That's just what I was thinking!" Pardo recalled. "She's a normal, everyday person." Caroline hugged another honoree, Marc Washington, after he broke down recalling his own brother's death, and urged him to "stay strong." Pardo felt Caroline "exuded this elegance and grace. [She] was absolutely kind."

An empty seat between Caroline and her uncle Ted seems to symbolize the absence of her brother at the Profile in Courage Award ceremony, May 22, 2000.

2000

"I have come to believe, more strongly than ever, that after people die, they really do live on through those who love them."
—CAROLINE KENNEDY SCHLOSSBERG

Now Caroline had the legacies of three beloved people to maintain—her father, her mother, and her brother. Just as she had assumed her mother's causes as her own, she stepped into John's shoes as well, presenting awards at his favorite charities. "She said she wanted to continue what John cared about," said one award recipient.

Friends and family say that her grief sometimes came close to crushing her. "Caroline is carrying a great emotional burden that needs time to heal," a friend said. "She's still in mourning, but she has to be there for her children and carry them through this."

Ed, Rose, Tatiana, and Jack—they had always been of paramount importance to Caroline. Now they were more so. Caroline fiercely protects her children from the intrusions of press and public, and—as her mother had with her and John—she attempts to give them as normal a life as possible. Still, there's only so much she can do. When her daughter Rose stuck her tongue out at photographers at John's funeral, it was eerily reminiscent of Caroline's similar protestations when she was a girl.

Few doubt that Caroline's children will emerge from the tragedy and the limelight as responsible, centered adults—just as she and her brother did. For Caroline, like Jackie, has been tempered by tragedy and shaped by the spotlight.

TOP Caroline presents former President Bush with a bust of her father as he is honored as a Distinguished American at the Kennedy Library, May 21, 2000.

BOTTOM Ted Kennedy, his wife, Vicki, and Caroline watch a tribute to her brother at the Profile in Courage Award ceremony on May 22. This year's recipient, California State Senator Hilda Solis, was the first woman to receive the award. "I know Caroline had a whole lot to do with that," said Elaine Jones, a fellow award committee member.

"She has a strong sense of personal responsibility," said the historian David McCullough, who also serves on the committee. "She knows she has serious work to do. And in that sense, I've always felt she is very much a Kennedy."

LEFT Caroline kisses her daughter Tatiana's head as they leave the Kennedy Library after the ceremony. The girl celebrated her tenth birthday on May 5.

Caroline's devastation at John's death was alleviated as much as possible by Ted's almost daily emotional support. Ever since the death of Bobby more than thirty years earlier, it had fallen to Ted to be the family's rock of strength through a seemingly never-ending series of tragedies. "Without Teddy," Caroline admitted late in 1999, after she performed the sad task of going through all of her brother's personal effects, "I don't think I could have gotten through the past few months."

BELOW Seven-year-old Jack Schlossberg helps his mother close the trunk of their car during a vacation in Kenmare County, Kerry, Ireland, on June 23. Just as Jackie had when she brought Caroline and John to Ireland, Caroline wanted her children to visit the land of their grandfather's heritage.

ABOVE On August 15, Caroline introduces her uncle Ted to the Democratic National Convention in Los Angeles. It had been forty years since another convention in that city had nominated her father for President. She had turned down an invitation to serve as chairwoman of the party's 1992 convention, but accepted this year in order to honor her brother and her uncle.

RIGHT After Caroline's remarks, Ted embraced and thanked her. Her appearance created a surge of emotion from the delegates as they cheered the last surviving member of Camelot's First Family.

Caroline and her daughters watch the action at the Hampton Classic Horse Show in Bridgehampton, Long Island, on September 3, 2000. Caroline's second cousin Joseph Gargan summed up her first year after her brother's death: "She is like a rock. She knows that John would want her to be strong and move on with her life. That's always been a Kennedy family message: to pick up and carry on."

Bibliography

✦

Adler, Bill. *The Uncommon Wisdom of Jacqueline Kennedy Onassis*. Secaucus, N.J.: Citadel Press, 1996.

Alderman, Ellen, and Caroline Kennedy. *In Our Defense*. New York: William Morrow, 1991.

———. *The Right to Privacy*. New York: Knopf, 1995.

Anderson, Christopher. *The Day John Died*. New York: William Morrow, 2000.

———. *Jack and Jackie*. New York: William Morrow, 1996.

———. *Jackie After Jack*. New York: William Morrow, 1998.

Anthony, Carl Sferrazza. *As We Remember Her*. New York: HarperCollins, 1997.

Collier, Peter, and David Horowitz. *The Kennedys*. New York: Summit Books, 1984.

Druitt, Michael. *John F. Kennedy Jr*. Kansas City: Andrews McMeel, 1999.

Heymann, C. David. *A Woman Named Jackie*. Secaucus, N.J.: Birch Lane Press, 1994.

Kennedy, Rose Fitzgerald. *Times to Remember*. Garden City, N.Y.: Doubleday, 1974.

Leigh, Wendy. *Prince Charming*. New York: Signet, 1999.

Mulvaney, Jay. *Kennedy Weddings*. New York: St. Martin's Press, 1999.

O'Donnell, Kenneth P., and David F. Powers with Joe McCarthy. *"Johnny, We Hardly Knew Ye."* New York: Little, Brown, 1973.

Shaw, Maud. *White House Nannie*. New York: New American Library, 1966.

Spada, James. *Jackie: Her Life in Pictures*. New York: St. Martin's Press, 2000.

Spoto, Donald. *Jacqueline Bouvier Kennedy Onassis*. New York: St. Martin's Press, 2000.

Taraborrelli, J. Randy. *Jackie, Ethel, Joan*. New York: Warner Books, 2000.

Teti, Frank, with text by Jeannie Sakol. *Kennedy: The Next Generation*. New York: Delilah, 1983.

Acknowledgments

❧

Researching in the John F. Kennedy Library's audiovisual department is inherently a rewarding—and fun—aspect of writing books about the Kennedys. It is made even more enjoyable by the presence of archivist James B. Hill. James is the kind of person who will warn you that he's so swamped with work "you may be on your own," and then pop his head in every five minutes to offer helpful suggestions or ask if you need anything more. This book is a better one because of him.

Another enjoyable aspect of research is that one sometimes crosses paths with fellow authors. While working on this book I met Carl Sferrazza Anthony, author of a number of books on the Kennedys and other White House occupants, and Jay Mulvaney, author of *Kennedy Weddings.* Both colleagues freely offered advice and assistance, and I thank them.

I'd also like to thank Melody Miller of Senator Edward M. Kennedy's office, who kindly allowed me access to my late friend Frank Teti's photo archives at the John F. Kennedy Library.

Jorge Jamarillo of Wide World Photos deserves special thanks for his accommodating and genial help in locating photographs. Others who went the extra mile to help me in my search for rare images were Henry McGee of Globe Photos, John Cronin of *The Boston Herald,* Michael Shulman of Getty-Liaison, Alex Moore of Corbis-Sygma, Ron and Howard Mandelbaum of Photofest, and Kathy Lavelle of Archive Photos.

As usual I owe a debt to my editor, Michael Denneny, and my agent, Todd Shuster, for their advice, encouragement, and belief in me. Christina Prestia at St. Martin's Press is an angel who keeps things running smoothly (even when there's no heat at 175 Fifth Avenue). Henry Yee has designed beautiful covers for my books, and James Sinclair and Gretchen Achilles beautiful interiors. Karen Gillis's exacting production standards have kept the books looking good.

Last but certainly not least, love and thanks to friends and family who have supported me through thick and thin: my partner, Terry Brown; my father, Joe Spada, and brother, Richard Spada; and my friends Richard Branson, Ned Keefe, Glen Sookiazian, Chris Nickens, Dan Conlon, Laura Van Wormer, Janet Smith, Christopher Mossey, Jamie Smarr, Michael Koegel, Nick Johnson, Kelly Costa, Dina Keith, Raphael Jaimes-Branger, Eliot Wright, and Simone Rene.

About the Author

⁂

JAMES SPADA is a writer and photographer with eighteen books to his credit, including internationally bestselling biographies of Barbra Streisand, Bette Davis, Peter Lawford, and Princess Grace of Monaco. He has compiled pictorial biographies of Ronald Reagan, Jackie Onassis, Katharine Hepburn, Robert Redford, Bette Midler, and Marilyn Monroe, among others. A book of his own work as a photographer, *Black & White Men,* was published in 2000.

Photo Credits

≫

Stephen P. Allen/Globe: 135(top)

Steve Allen/Getty-Liaison: 144, 148(top)

Elise Amendala/AP: 153, 178(top)

Archive Photos: 61(bottom), 81(top), 97(top)

Michel Artault/Getty-Liaison: 94

Daniel Aubrey/Getty-Liaison: 154

Author's Collection: 84 (bottom), 127, 163, 165

John Barrett/Globe: 137, 147 (top), 168, 170, 175

Paul R. Benoit/AP: 119(top)

Boston Herald: 91(bottom), 112, 119(bottom), 129(top), 149(bottom)

Jim Bourg/Archive: 192(top)

Henry Burroughs/AP: 16

Julie Burstein/Globe 117(top)

Laura Cavanaugh/Globe: 165(bottom), 174(top), 178(bottom), 179(top), 186, 194(bottom)

Shawn Considine/Globe: 141

Corbis-Bettmann: 143(bottom)

Corbis-Sygma: 118, 136(top), 186

Richard Corkery/*New York Daily News:* 109

Dixon/*Boston Herald:* 111

DMI/TimePix: 125(bottom), 132(top), 133(top), 142 (left), 145(bottom), 164(top)

Michael Ferguson/Globe: 171(both)

Ruth Fremson/AP: 173(bottom)

Getty-Liaison: 81(bottom), 85, 95, 176(bottom)

Peter Gould/Corbis-Sygma: 97(bottom)

Michael Grecco/*Boston Herald:* 130(both)

Chris Howard/AP: 174(bottom)

John F. Kennedy Library: 6, 7, 32, 138(bottom), 142(right), 145(top), 146(bottom), 162(bottom), 173(top), 177

Steve Klaver/Getty-Liaison: 132(bottom)

John Knudsen/John F. Kennedy Library: 14, 18, 20, 21(bottom), 23(top), 24, 28(bottom), 33, 45

Bertrand Laforet/Getty-Liaison: 93(top)

Marty Lederhandler/AP: 164(bottom)

Mark Lennihan/AP: 183

Henry Leridon/Getty-Liaison: 74

Don MacMonagle/AP: 193(bottom)

Darren McCollester/Getty-Liaison: 193(top)

Tyler Mallory/Getty-Liaison: 181(bottom)

George Martell/*Boston Herald:* 138(top)

Helaine Messer/Globe: 126(top)

Tom Middlemiss/AP: 126(bottom)

Thomas Monaster/*New York Daily News:* 140

Sonia Moskowitz/Globe: 110(bottom), 115, 179(bottom)

Norcia/Sygma: iv

Photofest: 13(bottom), 50, 52(bottom), 54(top), 67(top), 79(bottom), 83(bottom), 87(top), 89(bottom), 104(bottom)

Suzanne Plunkett/AP: 185

David Rannis/Globe: 105(bottom)

John Roca/*New York Daily News:* 195

Stephen Rose/PhotoCave.com: 151

Abbie Rowe/John F. Kennedy Library: 13(top), 41

David Ryan/AP: 160

Steven Savoia/AP: 176(top), 194(top)

Arnie Schlissel/Sygma: 161

Lawrence Schwartz/Getty-Liaison: 156, 181(top)

Lawrence Schwartz/Sygma: 162(top)

Adam Scull/Globe: 143(top)

Steven Senne/AP: 192(bottom)

Peter Southwick/*Boston Herald:* 114

Cecil Stoughton/John F. Kennedy Library: 17, 19(top), 21(top), 22, 23(bottom), 26, 27, 28(top), 29, 31, 35(top), 36

Mario Tama/Getty-Liaison: 182(bottom)

Frank Teti/Courtesy Melody Miller/John F. Kennedy Library: 83(top), 88, 89(top), 98, 103(both), 108(top)

Leo Tierney/*Boston Herald:* 110 (top)

TimePix: 5

Stanley Tretick/Sygma: 37

UPI-Bettmann: 64(top), 78(top), 82, 113, 128(top)

Nick Ut/AP: 172

Santi Visalli/Archive: 80

Patrick Whittemore/*Boston Herald:* 155

All other photographs are courtesy of AP/Wide World Photos